CHOCOLATES
from
Tangier

Jana Zimmer

CHOCOLATES
from
Tangier

A Holocaust replacement
child's memoir of art
and transformation

Dedication:
This is dedicated to both my parents, the
mystic and the cynic, my yin and my yang,
to thank them for their love, their endurance
and their courage in starting anew.

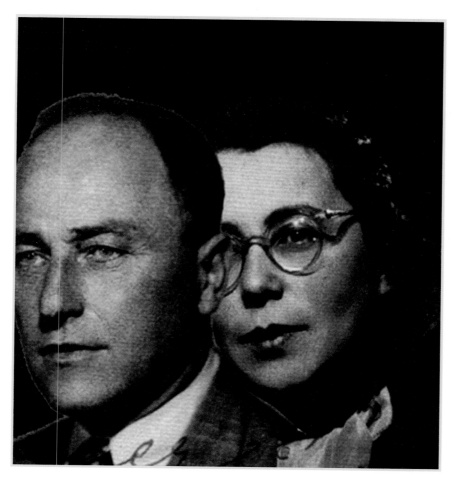

Josef and Klara, 1948

Chocolates from Tangier:

A Holocaust Replacement Child's Memoir of Art and Transformation

By Jana Zimmer

Text and images © 2023 Jana Zimmer

Book design: Alexandre Venacio
Typesetting: Olivia Perrault with Carrie Paterson
Printed by Mega Print

Publisher's Cataloging-in-Publication data
Names: Zimmer, Jana, author.
Title: Chocolates from Tangier : a Holocaust replacement child's memoir of art and transformation / by Jana Zimmer.
Description: Los Angeles, CA: DoppelHouse Press, 2023.
Identifiers: LCCN: 2022944544 | ISBN: 9781954600102 (paperback) | 9781954600119 (ebook)
Subjects: LCSH Zimmer, Jana. | Jewish women artists--United States--Biography. | Children of Holocaust survivors--Biography. | Holocaust, Jewish (1939-1945)--Czechoslovakia. | Auschwitz (Concentration camp) | BISAC BIOGRAPHY & AUTOBIOGRAPHY / Jewish | BIOGRAPHY & AUTOBIOGRAPHY / Personal Memoirs | ART / Women Artists | HISTORY / Holocaust
Classification: LCC D804.3 .Z56 2023 | DDC 940.53/1809253--dc23

DoppelHouse Press | Los Angeles
doppelhouse.com

Contents

Preface

"Mine are superficial roots, along the rail-
road tracks of Europe, through the paths of
emigration and deportation. Our roots are
diasporic. They do not go underground. They
are not attached to any particular land or
soil. Nor do they lie at the bottom of a
well in Jerusalem."
　　　—Henri Raczymow

The sages speak about each child coming into the world to mend
something in their family line and ultimately in the human family.
In essence, our lives are meant to be acts of what we Jews call *teshuvah,* of
turning toward a deeper and deeper level of healing.

I first began to make art when I was about fifty years old, with no
formal training. My father had been dead for more than a decade, and my
mother had come to live with me and my husband. I already had their life
stories, which they had recounted at my request—via tape recordings and
manuscripts—and my mother Klara brought a trove of family documents
and photos from Europe, which I began to incorporate into my first col-
lages and prints.

The words and images in this book orbit around two important
events in my life. The first was the exhibition of my art work in 2007
in my birthplace, Prague, and at the Terezín Ghetto Museum. These
exhibits were mainly inspired by my half-sister Ritta, who perished in
Auschwitz before I was born, and by my father's grief over that loss. The
other event, an exhibition of my art in Germany in 2015, along with that
of two other artists, included work created around my relationship to my
mother's experiences as survivor of Terezín, Auschwitz and Mauthausen,

and as a Jewish slave laborer in a Nazi aircraft factory in Freiberg, Saxony, beginning in October 1944. While these two exhibits occurred a decade apart, my experiences in making the art for them flowed back and forth from one to the other. They do not represent distinct and isolated points on a historical graph or lifeline. In fact, as I now look at them—and the artwork—from a distance, new variations continue to suggest themselves.

Although I have had both my parents' documents, photographs and their life stories written in manuscripts for many years, my understanding of them has also been altered by memories of my parents' oral histories, stories that they told me throughout their lives, as something arose to remind them. In my mother's case, I also have the video she recorded for the USC Shoah Foundation. There are often variations of detail which may completely transform my understanding of an event, or its meaning for me. For example, in my mother's written account she mentions, once, that when the American troops entered Mauthausen in May 1945, she received chocolates from one of the soldiers:

> "...a guy from New York, who spoke Yiddish, gave us a nice box of chocolates which we, according to experience in a camp, promptly ate. The chocolate and the liverwurst were a perfect combination for our digestive system, and we came out okay."

Her description of the encounter was almost dismissive, with an element of sly wit, but without any indication of the enormity of the moment. This was the way she regularly portrayed herself to the world. But on her video for the Shoah Foundation, which she recorded about ten years after her handwritten account, she recounted in detail how this soldier came to see her every day, and when it was time for his outfit to leave, he came to say goodbye especially to her. Just before leaving, he realized he had never introduced himself, formally. "I am Max," he said, and approached to shake her hand. Because she was so filthy and

lice ridden, she pulled back in shame. Max seized her hand and kissed it. And she cried, because this gesture helped her to feel human again. Unbeknownst to me, years later she told this story to my daughter-in-law Andréa, who announced that she would name her first baby Max, so that this American soldier's compassion would always be remembered in our family. And she did. After I heard the full story, I tried to find him or his family, but my mother only remembered he was from New York, and could not remember whether the soldier's last name was Greenberg or Rosenberg, so I gave up that search.

I didn't hear the most important story about the recurring significance of wartime gifts of chocolate until 1995—fifty years after the end of the war. Soon after she moved in with me, my mother read a book I had given her by Trudy Alexy called *The Mezuzzah in the Madonna's Foot: Marranos and Other Secret Jews*. I thought she would be interested, not so much because of Alexy's history of the crypto-Jews in Spain, but because Alexy's family, like ours, had its roots in the Austro-Hungarian empire, and she had spent her girlhood in Prague before they fled from Hitler, first to France, and then to Spain.

After devouring the book in one sitting, my mother came into my office, saying, in a frantic tone, "I have to show you something in that book."

In her book, Alexy had written about Mrs. Renée Reichmann, a wealthy Hungarian Jew who had escaped from Europe via Spain to Tangier in Morocco. Through the Spanish Red Cross, she began to send packages of food back to the deportees in the ghettos and concentration camps. In the chapter she devoted to Mrs. Reichmann, which she titled, "Our Woman in Tangier," Alexy described that when the Germans started deporting people from Czechoslovakia, the Gestapo used local Czech women to compile the lists of deportees.

My mother was a prisoner in the Terezín ghetto when she

received a package from Tangier, which contained chocolates, as valuable a commodity as cigarettes, which could be bartered for other food or medicine. My mother was amazed at the return address, as she knew no one in Tangier. Together, fifty years after the fact, we read that Mrs. Reichmann had a brother in Bratislava, and we deduced that my mother's name, along with that of my grandmother Elsa, must have been provided to Mrs. Reichmann through my mother's brother, my Uncle Bedřich (Fritz), who was then still free, and also living and working in Bratislava, while the rest of the family had been deported to Terezín in 1942. Fritz wasn't arrested until late 1944.

Regardless of the mysterious source of some of these gifts, my mother always filled out the pre-printed acknowledgment postcards that accompanied them, as was demanded by the Germans, because it was the only way to communicate to Fritz that they were still alive. Unlike most of the contents of packages sent to the inmates, which were stolen by the Germans, for no apparent reason these chocolates from Tangier were not confiscated.

On the opposite page, for example, is a card my mother wrote for my nearly blind grandmother to sign, addressed to Fritz, in Bratislava.

Theresienstadt (Terezín) December 16, 1943.

"My dear ones! — I acknowledge with thanks the receipt of your package of December, 1943. ~~Letter follows~~."

When she learned about Renée Reichmann's work, fifty years after her liberation from Mauthausen, my mother not only finally solved the mystery of the chocolates when she wasn't looking for it, but, in another surprising twist, she also learned from reading Alexy's book that after the Reichmann family left Morocco and immigrated to Canada, where we, too, had arrived in 1948, she and my father had probably met one of

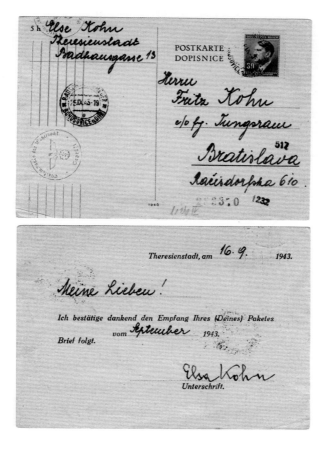

their sons, Edward. He was a friendly competitor of my father's in the tile business in Montreal. My parents had socialized with the Reichmanns on occasion, having them over for coffee and dessert on Sunday afternoons in the late 1950s, but they never spoke of their histories; no one was talking about the war then. In that moment in time, a connection was missed, when they might have shared so much.

When I read Alexy's book I was also surprised to find a connection to my own early history: on the last day before leaving Prague, in 1948, on our way to emigrate to Canada, my parents took me along in my

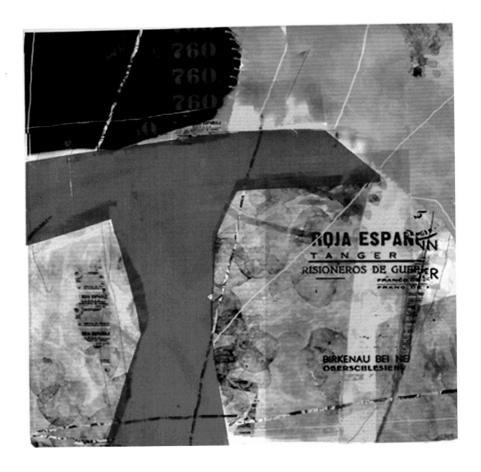

Prisioneros de Guerra (2011)
Digital collage from monotype

baby stroller to meet their dearest friends—also survivors of the camps—
to say goodbye at a favorite restaurant at the foot of Wenceslaus square.
In her book, Alexy describes going to that same restaurant as a child, and
she emphasizes her terror at having to jump on and off the Paternoster,
the tandem elevator made up of several individual doorless cabins, spaced
just a foot or two apart, attached to perpetually moving pulleys. One had

to jump on and off the open elevator cabins as they slowly passed by the exit on each floor. There are only a few of these left in Central Europe today.

My parents were leaving Prague legally, but somewhat clandestinely, fleeing the communists, and this meeting with their friends occurred at the restaurant and not at their home, because they had learned their housekeeper had been spying on them and reporting their plans to leave the country to the communist party. I can only imagine the intensity of their emotions and their nervousness that day, having to confront the fear and uncertainty of leaving their country. I was stunned to read about the Paternoster in Alexy's book, because the image of this bizarre machine had appeared in my earliest recurrent childhood nightmares. It terrified me as it had terrified Alexy. I had never seen a picture of it, so I had always thought I had conjured the contraption up in my imagination. It was not until I read the book, when I was almost fifty, that I realized my own anxiety dream had been based on a real threat to our safety and survival, that last day in Prague, from the elevator, as well as from the communists, who turned my parents from survivors into refugees, compounding the unfathomable trauma of the Holocaust.

Over the years I have made several collages, monotypes, assemblage, and digital collage inspired by the story of Mrs. Reichmann and the chocolates from Tangier. I incorporated fragments of an image of a mail tag that I found online, from Renée Reichmann, in Tangier, addressed to Birkenau Bei Neubrunn.

The fact that Mrs. Reichmann worked through the Spanish Red Cross and that the packages were labeled "Envio Para Prisioneros de Guerra" (Sent for Prisoners of War) was also explained in Alexy's book: the International Red Cross had refused to recognize the Jewish inmates of the camps and ghettos as prisoners of war and refused to deliver their shipments. They complained about the quality of the food. Mrs.

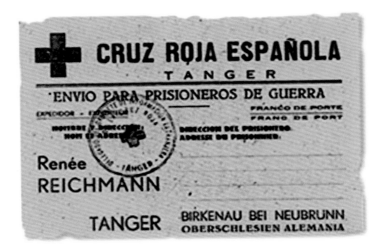

René Reichmann, Package addressed to
Birkenau, circa 1941

Reichmann's son told Alexy: "... they complained the chocolate was not up to their standards ... they did not consider where the food was going, that it was better than nothing, they just destroyed it!" The gift of chocolate that my mother received was certainly up to her standards, as a Jewish prisoner, starving in the Terezín ghetto. She considered it a small miracle, a moment of feeling that not everyone in the world was indifferent to her fate. Learning the source of these chocolates fifty years after the fact was another small miracle, bringing her a measure of peace with her past. The fact that we discovered this detail together was a great gift to me, as well, because it brought us closer in her last years, and opened me up to assembling the fragments of my own past.

"The world attacks us directly, tears us apart through the experience of the most incredible events, and assembles and reassembles us again. Collage is the most appropriate medium to illustrate this reality."

—Jiři Kolař (Czech poet and artist)

When I began to make art about my family's experience in the Holocaust, the first question I asked myself came from my accusatory, internal voice: "Who are you, Jana, to put this content in your work? These are not your experiences; these are not your memories. How do you dare appropriate this content?" I felt especially weighed down by this question in bringing my own artwork to the Terezín Ghetto, to hang in the same room which has held work by artists like Bedřich Fritta, who experienced these events directly and was compelled to record them at great risk to himself. I felt guilty and ashamed.

By way of response to my own accusation, and as if to justify myself, I offered a line from the Israeli film, "Under the Domim Tree":

"Some people want to forget where they've been; other people want to remember where they've never been."

Whether it is cellular memory or post-memory, or some other phenomenon, I have reassured myself that I'm not alone in my impulse, that my need to express this content is shared by others. And I have been encouraged by the reaction of those survivors who have seen my work, and who have told me they were moved by it, praising it as a way of restoring the voices of those who did not survive, and inspiring them to make their own testimony. Although I now can accept the legitimacy of my artistic voice, the dilemma remains for me and for all post-Holocaust

artists to portray, in an ethical way, events they never experienced—a vicarious past, "remembered" by them as stories told by parents, and in photos and writings of others.

A related accusatory question is one that begins with the dreaded phrases that make many a Jew cringe: "Why do you Jews always… " or, "Why do you Jews never… ?" In this case, it was a question asked of me by a lawyer colleague about thirty years ago. "Why do you Jews still insist on talking about the Holocaust? Why aren't you over this, Jana?" I think that the real question this person was asking was not, "Why aren't you over it," but "Why won't you let the world get over it, and let us all forget?" But I knew even then that forgetting is a prequel to denial.

I read recently that the French neuropsychiatrist and child survivor, Boris Cyrulnik said that "two great dangers threaten the children of the Shoah. The first is to speak about it; the second is not to speak about it." So, I had no answer for that man, all those years ago, but as a second-generation survivor I no longer feel the need to justify appropriating some details of my parents' experiences as subject matter in my art, and not letting go, but holding on, and continuing to remember. And, I believe that the right attitude in artistic representation requires me not to be over it. Because—as Holocaust scholars teach—in order to properly remember and to avoid trivializing the enormity of what was done to us and ours, we must resist our need for closure, we must sustain uncertainty, and learn to live without full understanding. This means that we have to resist our natural inclination and psychological need to make sense of things, to impose meaning or "lessons," to talk about the vindication of suffering through the transcendent power of art, or anything else our minds offer up.

This has also meant that my art has to remain specific by expressing the private narrative of individuals, and there are enough to choose from in my own family. This is because the impulse to universalize, or to

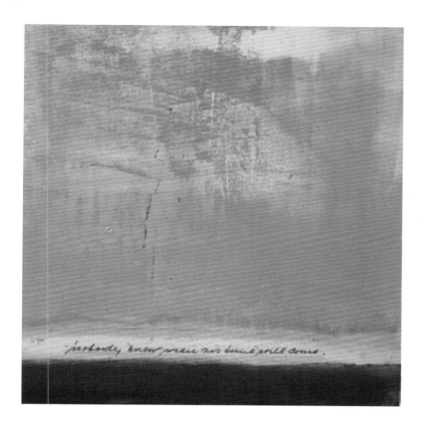

Nobody Knew (2015)
Collage on wood, 12 x 12 inches

reclaim broader meaning, can become an abuse of memory. Primo Levi wrote about an incident in Auschwitz where he impulsively asked an SS man why he had gratuitously struck a prisoner. "Warum?" Why? The response: "Hier ist kein Warum." Here, there is no why. To live with this answer and yet to avoid despair, has been a huge challenge in my life, and in my artwork.

The one immutable truth is that the losses of the Holocaust are the direct and immediate backdrop of my existence. Thus, the same "background" images keep coming up in my art, asking to be embellished

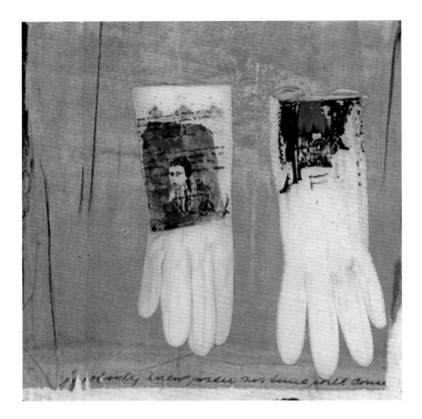

Nobody Knew When his Time will Come (2007)
Monotype with chine collé, 11 x 11 inches
Gift of Artist to Terezín Memorial

and explored in different contexts. So, the first time I used my father's words, "Nobody knew when his time will come," I placed them in a stark landscape, a simple monotype that I made for my exhibits in the Czech Republic in 2007.

In his writing, my father was referring to the fact that the Jews in the Terezín ghetto did not know when they would be ordered onto one of the transports to the death camps in the East. This sense of foreboding, of waiting for the other shoe to drop, has been the perennial backdrop of my own emotional life.

The phrase "Nobody knew" surfaces again in works inspired by my mother's experience. But there, I was compelled to add some softer, more expressive elements. My mother left me about a dozen pairs of kid leather gloves she had brought from Europe in 1948, which had lain at the bottom of a dresser drawer for decades. These gloves, along with photographs of the interior of her home, the family café, and the synagogue in Kroměříž became symbols in my later artwork of her life in prewar Europe before everything was lost, and they appear in many of the images I have made. The gloves stand in stark and elegant contrast to the dirt, hunger, grief and humiliation she endured and somehow survived, with her capacity for empathy intact. She always behaved in a civilized way.

On the seventieth anniversary of the liberation of the camps in 2015, I traveled to Germany to show my art in Freiberg, a town outside of Dresden, where a porcelain factory that had been owned by a Jew before the war had been converted by the Nazis to a slave labor camp. My mother was a prisoner there from October 1944 to April 1945, after more than two years in the Terezín ghetto, and after surviving a selection by Dr. Josef Mengele at Auschwitz II-Birkenau. I felt that I had completed an important part of my journey, having fulfilled my duty to memory and history, and that I had found my place between my parents, the world they left me, and the lives they lived through.

I was very disciplined and faithful to my duty to be literal in my Terezín exhibit, but it was only recently, when I reviewed the imagery and my writing about it, that I perceived an instinct to transform their experience, or at least to go beyond the outcome. As I shifted focus in my artwork between the exhibits in Terezín/Prague and then Germany, effectively moving from my father's story to my mother's, I experienced more attention to emotional and spiritual detail than to the historical facts, and I wonder what that might mean in terms of my own evolution

in relation to this horrible backstory. I also need to remain open to the gift of new insights and understandings, as they emerge from the historical details, sometimes in the most unexpected ways. And I feel I need to close a circle, and I am running out of time.

To the extent that this is a memoir, then, it is based on my own imperfect memory rather than historical truth. Because it treads upon the sacred memory of the Shoah, I must stress that its purpose is not to transform or redeem the horror perpetrated against my family, either through the juxtaposition of my parents' words with my own, or their images in my art. In this, it must instead remain faithful to their lived experience. Indeed, in a few instances I have retained my mother's possibly erroneous memory of a detail, despite suggested "corrections" from historians and researchers who have questioned the accuracy of her recollection. The one example that weighs on my mind today is her recollection that it was a Russian army jeep which first entered the Mauthausen concentration camp in May 1945, ahead of the Americans.

She said,

```
"We were in the barracks when the first Russian
jeep passed our window and we saw freedom coming at last.
Whatever the Russians did later or will ever do, I will
never forget the most thankful feeling."
```

"Or ever will do..." I have to wonder, in light of what the Russians did in Hungary in 1956, in Czechoslovakia in 1968, and now in Ukraine, whether that feeling of gratitude would have been buried in bitterness. But it is not for me to change or to correct my parents' memories. The only transformation I seek within this framework of telling, imagining and re-imagining, is my own transformation and, possibly, my redemption from Exile.

Untitled (2018)
Digital Collage

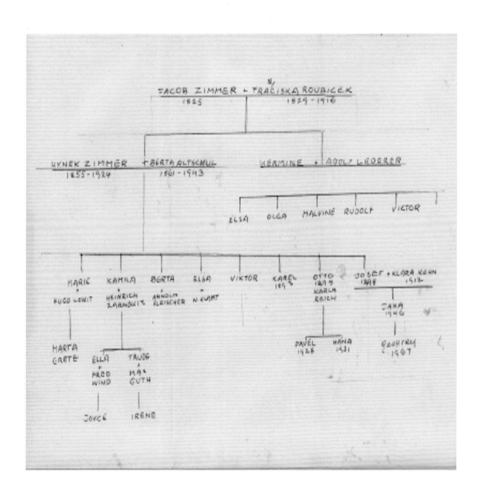

Zimmer Family Tree [drawn by Josef Zimmer, circa 1981]

My father drew these family trees for me. I notice now that he has completely erased his first wife, and my half sister, Ritta, from this history.

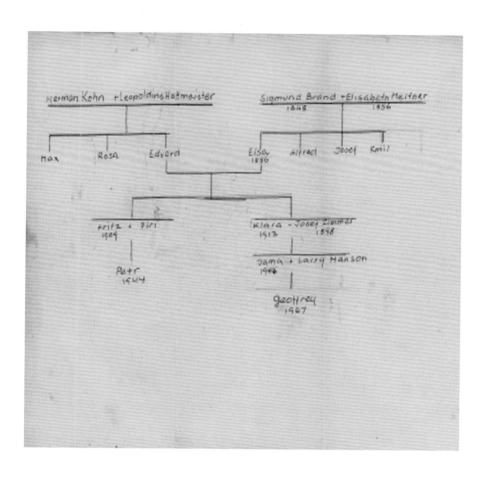

Kohn Family Tree [drawn by Josef Zimmer, circa 1981]

Similarly, here, he has excluded Alfred Loeff, my mother's first husband.

Multi-Generational Transmission of Trauma #1 (2006)
Monotype, 11 x 11 inches

What She Was Thinking

Looking out onto the world as a child I saw not a field of possibilities but a vast emptiness, and there was always silence. There were no answers to my questions. Not about where babies came from or why everyone else had a grandmother, aunts, uncles and cousins, and I did not. I was not taught to want or expect anything. Or, more accurately perhaps, I was taught to not want anything, as I observed my parents not-wanting. And my father was taciturn, except when he was with his friends from the camps, when they would laugh uproariously over the memory of being beaten to the point of shitting their pants in fear, or at some other hazard or humiliation. When I came to understand what the German word "Lager" meant, this constant, maniacal laughter was confusing. Whenever they started a sentence with the phrase, "Im Lager" (in the camp), the wind shifted and chilled me. How could they be laughing so uproariously at such horrors? I understood their words, but the context was a universe I couldn't comprehend.

My mother was the enforcer of my father's very traditional expectations of me. He wanted me to have a "good" education, which he portrayed as an insurance policy, in case I failed to find a husband. But there were no thoughts of rebellion in me. I was conscious only of a

small constriction; never investigated, never pursued. I don't remember either of them asking me what I wanted to do in life, or what I dreamed of. These negations of imagination and desire did not seem different from what other girls of my generation endured from mothers unsympathetic to their romantic aspirations, so I was not aware of the difference in degree. When we are growing up, we are not truly conscious that our peers may be having a fundamentally different childhood from our own.

My mother did what she knew how to do and gave me everything she could to expand my horizons, within a traditional nineteenth-century European framework. I had private lessons in French, German, ballet and piano. I learned to ski and ride horses. I went to public schools in Montreal, which were free and quite adequate, and she took in sewing to pay for all these extras. At thirteen, I was becoming well-rounded. I would have made an excellent Dauphine of France, circa 1789. The summer after my first year in college, I was required to learn to type, too, in case life did not turn out well and condemned me to being "just" a secretary. In this, I am sure my parents were mindful of the limitations that had been placed on their own mothers. But there were always paradoxical reactions, such as when I became pregnant as I was finishing college at the age of twenty, my father started to cry, saying, "[T]here goes your master's degree."

My father had loved and respected his own mother immensely, and he seemed embittered on her behalf by the limitations she had faced. He wrote:

"Considering the circumstances and conditions in the family I can imagine how miserable and hopeless was my mother's life. She was a very fine, educated person and why she had married my father, a man without any education, with more bad habits than good ones, completely without ambition, with five children of which the oldest was six years old, I will never understand. Maybe because she was thirty-one

1. What She Was Thinking

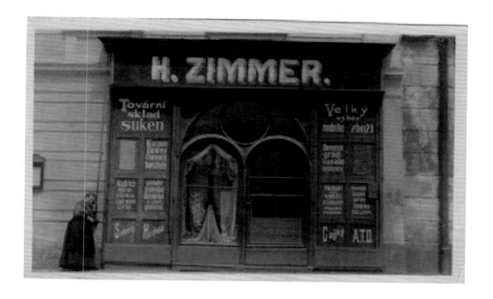

Berta Altshul Zimmer, Family Store
Soběslav, Bohemia (undated)

years old already and herself did not have the opportunity
or desire to find a man for herself, her family forced her
into this marriage..."

She rose to the occasion. In addition to birthing three more sons
in quick succession for my grandfather Hynek, she occupied herself in
managing the family store:

"Although she had no experience in business or in
business dealings with the small farmers who were customers
in our little store, she soon took over the management...
But considering the disability my father had shown to
make something better of himself or with the business she
adjusted herself to the facts."

It wasn't until I enlarged this photograph of the family store in
Soběslav that I noticed my grandmother, Berta, in the lower left-hand corner.

"Can You Hear Me, Now?" (2005)
Monotype with chine collé, 18 x 24 inches

My maternal grandfather, Eduard Kohn, had been killed in World War I and my grandmother, Elsa, along with my mother and her older brother, Fritz, were taken in and cared for by Uncle Emil Brand.

1. What She Was Thinking

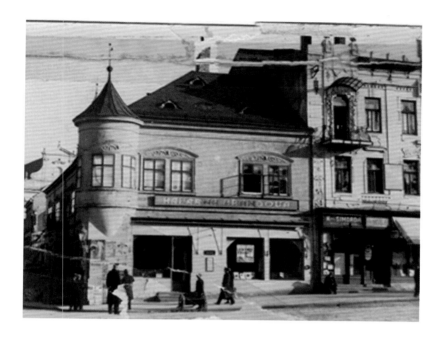

Kavárna Brándova, Kroměříž, Moravia
(undated)

They all lived above the family café, Kavárna Brándova, in Kroměříž, Moravia.

The café had been built by my great-grandfather Sigmund Brand on the corner of Vodní Street, where it runs into the main town square, Velký Náměstí. My mother, who grew up surrounded by family, wrote:

"First of all, there was Grandpa, Sigmund Brand — born 1848. Extremely handsome, he resembled Kaiser Franz Joseph of Austria. An old man, who ran the whole family. By profession, a coffeehouse proprietor, in business — as in private life — he just wanted everything perfect. Everybody was afraid of him except me, his pet, and therefore the only one who could tell him since way back to stop yelling, which was the only way he liked to communicate."

My mother's descriptions of her childhood are idyllic, even though she and Fritz were both sickly and completely dependent on their uncle's generosity for their education and the food on their table. The main source of happiness that Klara had, and something that was absent in my life, was a large, devoted family. There were rarely less than ten people around the dinner table in the café, and as she was Grandpa Sigmund's favorite, she felt loved and taken care of. So the quality she always emphasized was loyalty and contribution within the family unit. By contrast, I had a deeply lonely childhood, but I still inherited the commitment to family that she exemplified.

Eventually, Uncle Emil married a forward-looking woman named Nettie Heutler. After worrying at first how she would fit into the family, my mother came to adore Aunt Nettie for her kindness and ingenuity:

"As was rather common in a situation like my mother's, being a widow with kids without income, living with relatives, whenever mother needed money for herself, she told the family and took it from the cash register.

"But Aunt Nettie suggested a different solution. She thought, and rightly so, that it would be a morale booster for mother to have her own income. So, she made her a legal partner in her store for whatever they would make, and, in case of trouble, Uncle Emil had to stand by with financial help. Mother would continue to work in the coffeehouse, and everybody was very happy. When I grew up and understood it better, I was forever grateful to Aunt Nettie for Mama. No wonder I had to be in the store too!"

Not that being a seamstress had been my mother's first choice. She did very well in school and was interested in everything except sewing and domestic needlecrafts. But when a new law required all clothing manufacturers to have a license, my mother was taken out of high school and moved to a trade school:

1. What She Was Thinking

"So, Klara left high school after finishing the third year, which was okay, I got the license."

This is the only time in her writing that she referred to herself in the third person. "Klara left high school...which was okay." She had loved school so much that she always arrived early, before the custodian unlocked the doors. But a decision had been made about her future by the family. She showed no resentment of the fact that her brother Fritz went on to higher studies, as was the custom. And she always relished the feeling of independence she had from the skills she'd learned. When I was growing up, she had her own money from her dressmaking, which she put away in a yellow straw purse in her night table. When I wanted something, she didn't have to ask my father for money; she told me to go and get a few dollar bills—she charged a dollar a hem—from the yellow purse.

One of her favorite maxims when I was growing up—and which irritated me to no end—was: "If you can't do what you like, like what you do." I didn't know until very late in her life, when she confided in my daughter-in-law, that my mother had dreams of her own when she was young that had been impossible to pursue. She wanted to be a lawyer, which is the career I eventually chose after a false start into the more "female" profession of teaching French.

I don't know to this day if the choked, blank space in my mind where desire or commitment to a dream would have lived when I was younger was part of an inherited, primitive superstition, or a survivor tic—as in: "Don't expect anything of the world. We just wanted to live our lives and look what happened to us." Maybe it was because I was female and my horizon was automatically limited by my gender, certainly in my parents' eyes. My parents' dreams for me were small and safe—career choices dictated not by my own ambitions in life (if I had known what

Memories Like Rain (2013)
Digital collage

they were), but by the chance that my husband, if I found one, might die and leave me to support myself. Art, music, and theater were never options. At one point in my teens my mother suggested that I become a physical therapist; not a doctor or even a nurse. A profession was only as good as the security it provided.

But my parents were, at least, intent on my having a good education. I see now that their deep loyalty to their families and the external constraints of being born at the turn of the twentieth century dictated

their decisions on the course of their lives. Regardless, whatever I was or was not offered as options, I was an obedient little girl. I looked happy enough in early photos. In this digital collage I overlaid my father's writing, describing when he lost hope of finding his first child alive. His loss hung like a veil over my natural exuberance.

Like most children, I fantasized from time to time that I had been adopted. But my mother used to hold her fist to her face exactly like I did in this photo, so I know I was hers.

At about the age of eight, when I was rummaging around my parents' bedroom in their absence, I found a picture of my half-sister, Ritta. I was specifically and angrily told by my mother: "Never, never, never ask Daddy about her..." so I never did. Nor did I ask about anything else. This picture of Ritta, and an oil painting of a dark forest that my parents had brought from Prague and hung on their wall, are the two objects I retrieve most easily from my memories of childhood. They are both sad and mysterious, and they are both about the silence and the dark past. I only saw the photo of Ritta twice, the first time when I was a child, and a second time after I finally communicated to my father that I knew about her. That is when he gave it to me; I was about thirty-five. He brought it in to the kitchen and carefully wrote the year of her birth, and the year and place of her death on the back as I stood and waited. The print is unclear, but the writing is firm and precise. He made sure to add the year that it was taken. 1939. He didn't say a word, and I couldn't speak, not even to say thank you. My throat closed.

The forest painting followed us from Prague to Montreal in 1948, and then to California, in 1963, and it stayed on my mother's wall until she died. I had stared into it every day growing up, and every time I was in the living room of our house, wondering what had happened in that dark place. The forest looked empty, but something was lurking there.

Marketa (Ritta) Zimmerova (1932–1944)
October 1939
[Back of photograph, dates written by
Josef Zimmer, circa 1974]

Forest Painting #1
Artist Unknown

1. What She Was Thinking

As I grew from childhood to adolescence to early adulthood I would overhear my mother, in conversation with her survivor friends, referring to my father's first wife, Kitty, and to Ritta, always in a near whisper. They always stopped talking when I entered the room. I didn't know and never asked who either of them were, and what relation to us. I understood they must be part of a painful secret, one so terrible that it would kill my father if it were mentioned aloud. I will never know how much his grief and guilt over not being able to protect his family colored his ability to attach to me. My mother kept insisting to everyone how much he loved me. He never once told me.

My father described returning to Prague after the end of the war:

"Before 7 a.m. we were in Prague on May 18, 1945. At last. I went to the Jewish community center to find out if my family had already returned. They did not have any news and told me that there are still many people in Terezín taking care of the sick.

"Next morning, I took the train to Terezín full of hopes that Kitty and Ritta will be there. They were not. I found out from my mother-in-law who was still there that in a few days after I left the Germans put together a transport of our families and nobody in Terezín knew where the transport went. Some people maintained that it went to Auschwitz. If that was true, there was no hope. I hoped that they went somewhere else and that they will return. There were still people returning from different places in Europe. But considering that Ritta was 12 years old I was afraid of the worst. Unfortunately, it came to the worst."

I don't know when he gave up hope. I know he had to publish a death notice for Kitty in order to marry my mother, and that there was one published for Ritta, too, in 1946. It says that she was deported to Terezín due to racial persecution, and from there to Auschwitz in

October 1944, and it concludes, "od té doby není od ní sprav," which means, "since that time there has been no news from her."

In Montreal, unlike the many immigrant survivors who pretended to be other than who they were and attended the Unitarian Church to "pass" for Gentile, my parents did not renounce their Jewishness or try to hide it, but they were never integrated into the Canadian Jewish community either. They only socialized with other Czech survivor families, and did not go to synagogue, except that my mother unfailingly attended Yizkor—the memorial service for the dead, on Yom Kippur. Unlike my Canadian-born contemporaries, they did not offer me any Jewish education, nor did they try to control my social relationships with non-Jews. At the time, I was glad they didn't send me to Czech language and culture school, like the other immigrant children. My father thought it pointless and severed all such ties to Czechoslovakia as he did not imagine the Communists would ever leave. Many times over the past thirty years I have wished I had that language training, just as I wish I had allowed my mother to teach me to knit, sew and cook, all things that would bring me closer to her, closer to home.

I had creative inclinations as a child. But, in my journal I describe how, after early encouragement, artmaking became a thing associated with humiliation. When I was six, I was excited because a reporter was coming to take photos of the first-grade student artists at Van Horne elementary school. The parents were to be there, as well. I was already embarrassed of my mother's differentness: her age (at forty she appeared much older than the other parents), her foreign accent and her unruly Jewish hair, which had grown back prematurely gray after they'd shaved her head at Auschwitz. She had come to volunteer in my art class, but she tripped and fell, spilling a whole muffin tray of poster paints on the floor. I didn't see whether she was hurt; I saw only that she was sprawled on the floor, the center of negative attention, among the puddles of splattered

paint. That was it. I never tried to make art for another forty-five years, nor was I encouraged to do so.

My mother, I later learned, was not troubled at all by the memory of this incident and had kept the clipping from the Montreal Gazette, complete with my picture. There I was, in my home-sewn navy-blue sailor suit, pleated skirt and white collar, standing in front of my artwork. She pasted it into the same red, faux leather-covered scrapbook, where decades later she carefully pasted stories of my small triumphs in the legal profession. She often said she was proud of me. But after the first grade, and the change to a new school where I was even more out of place among the wealthier, Anglophone Protestant students, I moved through my childhood and adolescence in a rote, colorless fog, fearful of being singled out.

Apart from the disaster with the poster paints, my experience with music, too, was tainted by my immigrant past. I enjoyed my piano lessons, which started when I was about seven, and I was making good progress, but that ended in humiliation too. My teacher decided that I should have the honor to play both "God Save the Queen" and "O! Canada" at my first recital and introduced me as "our little refugee" from Czechoslovakia. She wanted me to act grateful, whether to Canada or to her wasn't clear. I wasn't. I didn't want to be "from" anywhere else. I wanted to belong more than I wanted anything. At the recital, I banged away at the angriest version of "God Save the Queen" ever played. I continued the lessons for a couple of years but refused to practice and was soon relieved of them.

My preteen years were punctuated by visits to the House of Wong up on Queen Mary Road for eggrolls every two weeks. This treat always followed ballet with Miss Milenka, then piano with Mrs. Shoobridge, conveniently situated in the same building on Decarie Boulevard, and then a visit to the orthodontist, two blocks away. After collecting me,

and another volume of the Encyclopedia Britannica purchased with green stamps from the supermarket, my mother packed the Chinese food and the groceries into a taxi that delivered us to our house through the snow. I remember the bitter cold and the darkness—night fell at 4:30 in a Montreal winter—as well as the glittering light from the streetlamps on the snow, and the smell of the eggrolls mixed with our steamy breath in the back of the taxi. We only had one family car, which after a 1949 Pontiac was a Chevrolet Impala, replaced every two years, which Daddy took to work. My mother didn't learn to drive until after we moved to California.

My high school days flowed by in a nondescript routine. I achieved good grades without much effort, and most of my time was spent fretting about where I might go to socialize, and with whom. The non-Jewish girls who were reasonably friendly at school never invited Jews to their homes on the weekend. There were not many invitations from the Jewish girls either—most of them Canadians for at least two generations more than me, none of them with parents who spoke English with an accent or had numbers tattooed on their arm. They all lived well within the boundaries of the staid and solidly middle-class town of Mount Royal, while our little half a duplex was just outside, across Lucerne Road, the dividing line between the haves and the haves-less.

Early in my teen years, there seemed never to be anything to do. The Catholic Church, all-powerful in Quebec, ordained that children under sixteen could not attend the cinema except for the occasional Disney film. I spent Saturdays riding horses with my friend Karen from across the street, without understanding why cantering the horse was so pleasurable. And I devoted Sunday afternoons to surreptitiously reading Peyton Place when my parents were out playing cards, without understanding any of the steamy sex scenes. My mother never got around to having the sex talk with me.

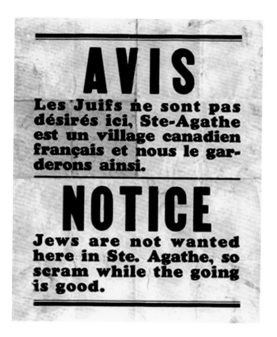

I think Karen was the only non-Jew in our little subdivision, and one of a tiny handful of steady friends at that time. She was a misfit, too, only interested in horses. We took two or three streetcars to reach the stables in what was then the "outskirts" of the city. Some Saturdays, my parents drove us up to Sainte-Agathe-des-Montes to go skiing in the Laurentian Mountains, which were less than an hour from home. Karen's father was friendly with the owner of the staid Laurentide Inn, and my parents would drop us at the slopes and then go sit by the fire in their lobby while we skied. We, or at least I, had no idea then that the inn was restricted—no Jews or dogs were allowed. There was signage to this effect in the village (see above). I think my father knew of these restrictions and got a good deal of pleasure out of sitting on their cozy leather couches all afternoon, eating European deli, accompanied by our miniature poodle, Jackie. So it is that the smell of eggrolls, Players' cigarettes, and smoked

meat on rye from Ben's Delicatessen provide my strongest recollections of the decade from 1953–63.

I notice the French version of the No Jews Allowed sign is not quite as menacing as the English: "...Ste-Agathe is a French-Canadian village and we will keep it that way." I don't know if my parents ever saw a sign like this. If they did, they never let on to me.

There was one major event that was to change my life forever, though, and that happened in summer 1959 when I was almost thirteen. After my parents' financial situation improved, we had stopped going to the Laurentians and instead would spend a few weeks during the summer in shared cottages with other Czech friends on Cape Cod, near Hyannisport. Unusually that year, we visited California, driving up Highway 1 from San Diego to San Francisco in a white Impala convertible, which my father had rented because it was the vehicle I most desired. This was a rare indulgence on his part of my adolescent, Hollywood-fueled desires. We stopped to visit an elderly relative named Elsa Klamt in the mountains near Santa Cruz; she was one of the older half-sisters from my grandfather Hynek's first marriage. A widow, Elsa lived alone in a cabin in the woods. In his life manuscript, my father said only that Mr. Klamt had been a flower grower, and that Elsa died childless in the 1960s. She was the last surviving remnant of the Zimmers.

From that summer onward, I agitated relentlessly to move to California. My dream of living a different life coincided with a deterioration in my sixty-five-year-old father's health, which required him to escape the brutality of the Canadian winter. With severe angina from atherosclerosis, he could no longer manage to shovel snow morning and night in wintertime just to get the car in and out of the driveway. My mother and I had to take over that chore, and neither of us enjoyed it. But I didn't complain. Seeing my father pull out the little brown bottle of

nitrogylcerin to alleviate his chest pain triggered a deep fear of his immi-
nent death. Since my discovery of the photo of Ritta when I was a little
girl, I became convinced that something I did, or didn't do, would cause
him to die.

So in 1963 we pulled up stakes and left Montreal for San Diego.
I was sure that in California I could start over. I could be normal. I would
not be Jewish, or different in any way, or have frizzy hair, or a gap in my
teeth. Or oversized breasts. I would be athletic. I would tan and not burn,
I would have a boyfriend. My parents did not talk to me about moving,
or about my hopes or fears, but I was very happy when they announced
their decision. I felt no sadness at leaving, not even at leaving my few
friends. I thought something magical would happen when I got off the
airplane, and my life would be transformed. I would belong.

That did not happen. San Diego was a very conservative town,
dominated in those days by its connection to the Navy and the defense
industry. Not very many Jews, but a lot of bigots. In Montreal, apart
from being an immigrant Jew living among the whitest of white English-
speaking Protestants, I'd had no experience with racial difference, except
for ogling Bismarc Carrington, a very handsome, talented boy from the
Caribbean who was a star on my high school football team. I had not
thought of San Diego as being part of the infamous American "South,"
but when I began to notice how white San Diego was, and how seg-
regated, I was reminded that if you drew a line of latitude across the
United States, San Diego actually fell below the Mason-Dixon line. That
explained a lot. And when JFK was assassinated a few months after we
arrived and then the young Civil Rights activists Schwerner, Chaney and
Goodman—two of them Jewish—were murdered in Mississippi in 1964,
that line didn't seem far away at all. My fantasies about the America I
knew from Hollywood fan magazines began to unravel ever faster with
the Watts rebellion in 1965 and then the ongoing Vietnam War. When,

at not quite eighteen, I became involved with Civil Rights work and, later, anti-war protests, my father became convinced that we would all be deported, but my mother stood firm and thought it important that I participate. In fact, she directed me to attend my first Civil Rights march, saying, "You know what happened to us, because no one stood up for us. You get down there."

I did not think about anti-Semitism much but it came after me, in school, with random ignorant comments, and when I was rejected from "white" sororities and honor societies, even though my grades were very good. It didn't quite register that it was because I was a Jew. I thought it was because I wasn't pretty enough. I cringed at the idea of joining the Jewish sorority, not because I would be a target, but because I didn't feel part of that community either. In Montreal, the Jewish girls seemed pre-occupied with marriage and fur coats. I knew I wanted something more. So instead, I gravitated toward the students involved in politics, along with the international students. My parents didn't seem to take much notice and remained silent even when I dated young men from Jordan, Iran and Algeria, briefly. Those friendships ended when the men—who were in their mid-twenties to my very innocent seventeen, had to accept that being a peace-loving Jew did not make me available for sexual favors.

After a lonely adolescence, and after my first year of college in San Diego, I straightened my hair and my nose, and at the age of nineteen I married a native-born American, with Pennsylvania Dutch roots going back to the Revolutionary war. I thought it would help me belong. I flinched whenever I heard casual anti-Semitic comments, but I put away anything connected to my Jewishness or my family's history. I wanted to be "normal." My parents objected to my marriage initially, not on grounds of religion, but because of my age and immaturity, and their fear that I would abandon my education. I did not. I graduated from college eight

months' pregnant and received my master's degree in French literature before my son, Geoffrey, turned two. I was hurt but not surprised that they seemed to have so little faith in me, and I was determined to prove them wrong.

When I was in my mid-twenties and, as I now realize, very depressed, I started a journal in which I self-consciously wrote whatever came into my head in very, very small, cramped script. It is something I still possess but have always hidden away, even though I fantasized that someday my thoughts would be worthy of being read. Now I plan to burn it before I die. My writing in this journal coincided with the beginning of the end of my first marriage. I did not write much about my earliest memories. I didn't and don't have many, although the older I get, the more fragments and seemingly random details pop up.

For instance, I see now that I gave a half-page in the journal to Uncle Karel, my father's older brother, who'd returned from India in 1951 only to begin to die at our kitchen table in Montreal one morning, completing the process within days at the Jewish General Hospital up on Côte des Neiges Road. I only remember his death rattle. My parents referred to him very briefly in their life stories. He is the only close relative on my father's side who had escaped the Nazis, and the only one I ever met. Maybe that is why the memory of his dying seems so vivid.

My father summarized Karel's life succinctly, and with no self-consciousness about the judgments he made about his older brother:

"Karel was a very weak and sickly child. When he was fourteen, he enrolled in a business school in Vienna where he graduated as a very sick youngster. He developed tuberculosis and spent the next two years in Soběslav where mother cured him with lots of goat's milk and fresh air. Naturally he became mother's worry and number one child. He was cured completely and pretty successful in his job as a salesman in the crockery business. He was drafted into the army in

1914, went through the war unharmed, and returned to his job in 1920. He married in 1930 a rich, spoiled girl who didn't like him. She was an orphan and agreed to marry him because her relatives talked her into the marriage to get rid of her. He was too devoted to mother and compared his wife to mother in everything she did or said. Naturally, the marriage ended in divorce after two years.

"He was lucky to escape the Nazi time by emigrating to America. He didn't succeed and returned in 1947 to Prague where I helped him to get a very good job. Somehow it didn't work out and he lost or quit his job in 1949. He met some people from India who made him believe that he could make a fortune there in the import-export business. He went there, failed, and came to Montreal. Due to his experience in the ceramics business, he got a job as a sales agent for a ceramics factory in Quebec city. But he died of heart failure in 1951 at the age of fifty-eight."

I don't have a memory of either of my parents speaking of Karel after his death, but his brief presence in our home made a big impression on me. I remember being frightened, pressing my face into the bright red paint of the breakfast nook bench, trying to escape the sound of his uncontrollable coughing. They didn't tell me what was happening then, or ever. I still have a few small ivory figurines that he brought from Calcutta. One is of Guan Yin, the goddess of compassion, one is Shiva the destroyer, and one is of Ganesh, the elephant god. I gave Ganesh to my son for good luck, or, at least to ward off bad luck. The goddesses remain on my shelf, flanking a candle for meditation, when I remember to do it, alongside my mother's Jewish spice box and my grandmother Elsa's blue Czech glass wedding plate and decanter; a gift from the town priest in Kroměříž in about 1906. I don't know what to do about the fact that it is now considered a crime against nature to possess ivory, no matter how old, so I choose not to think about this when I look at these

objects. For better or worse, they are part of my connection to my family, and the past.

As time went on, I learned to internalize the silence around me, both about the past and about everything else, to the point where even as an adult I could not articulate thoughts or feelings about my half-sister, Ritta, and the war (the two things I was not supposed to ask about) in a language my parents might understand. It would hurt them too much. That is why, when I was in my twenties and in graduate school, I wrote my one published poem in French. My parents spoke Czech, German and English, but not a word of French. I addressed the poem to my mother—"Maminko"—but I was speaking through her to my father, "Tato," as I had always felt obligated to do.

I had written in French once before about a trip to Czechoslovakia in 1971 with my first husband, Larry, and my parents, before I started writing in the journal. We had gone to Terezín together, my first visit to the ghetto, where I found that I couldn't say a word; not when we were there and not afterward. It was the first time we had been back there since we left Prague in 1948. I wrote that during our visit, in certain moments—"Ils ont réussi à me faire revivre ce qu'ils avaient vécu"—they had succeeded in making me relive what they had gone through, as though it were the second time for me as well. That statement shocks me now, but it didn't then. It was just what I was experiencing. That, and the feeling that I could not speak at all. At the time I did not find it strange that I was hiding my writing, and my feelings, from everyone. I didn't feel I had any other option.

When I started my journal after the trip to Czechoslovakia, I was twenty-five, a graduate student in French literature and linguistics. Graduate school had been the easiest of all choices. In our senior year at San Diego State, Larry had been classified 1A, which meant he was eligible for immediate induction to the Army in the fall of 1966,

when the war machine was swallowing 50,000 young men a month, so our options were limited. We could leave the country together, heading back to Canada where I was still a citizen, or join the Peace Corps and go somewhere like Senegal, where I could use my French. Or we could have a child, get married, and go to graduate school, thus deferring his military service, and all decisions about the purpose of our lives. My pregnancy test came back positive the same week we were accepted into the Peace Corps. So graduate school it had to be, but it was clear I was not fit for a "life of the mind."

I was restless, and dismissive of the intellectual giants of philosophy and literary criticism whose work I was studying—Foucault, Lacan, Barthes. But the creative relationships among the poets and the painters—Mallarmé, Eluard, Apollinaire, Chagall, Max Ernst—sparked something in me; a desire to play with words and images together that I did not pursue at the time. I couldn't imagine how I would begin. I played with my ideas in a couple of the papers I submitted to qualify for my doctorate, and I completed all the exams and course work, but I flailed around and never completed my dissertation. I managed to alienate three dissertation advisors in succession, so I had to change my area of study thrice over. My professors were not appreciative of my obsession with seeking justice beyond the seminar room. And I was contemptuous of their posturing and affectations.

Outside my office window, the anti-Vietnam War movement and what felt like "real life" was passing me by. I felt trapped in an identity I hadn't chosen but entered into by default, in a life I should have been grateful for, but wasn't. As aimless as I was, when I had to declare an undergraduate major, I had chosen French because I had been compelled to learn it as a child in Quebec, so it was easy for me. I continued with it into the Ph.D. program without really wanting anything that could come from it. To be a French teacher or an academic, to smoke Gauloises, to

ponder the films of Jodorowski—none of these things held any charm for me. I scorned it. I felt superior to it, with no objective justification. I was sure that I was destined for more important things. Required to do more important things. But I did not know what. I felt guilty.

One gray, foggy day as I sat in my gray office with the gray metal furniture on the fifth floor of Phelps Hall at UC Santa Barbara, I read that when the French surrealist poet Robert Desnos was dying of typhus in Terezín, a month after liberation in 1945, he was talking about surrealism. That would have been about the time my father, just back from the death march from Auschwitz, took the train from Prague to Terezín to look for his wife and daughter. I wrote a very angry poem about this, in one sitting. The words flowed out of me as though I was practicing automatism, an early surrealist technique. I submitted my poem to a small literary journal at the University of Kansas called *Chimères*. On a whim, I signed my name Jana Z. Manson, combining the Czech version of my first name, my father's initial, and my first husband's surname, which I had been happy to take upon marriage because I thought it normalized me. Using my Czech first name to sign the poem was the first inkling I had that I wanted to return to my birth name.

When my parents had arrived in Canada from Prague after the war, they had anglicized my name on my citizenship papers. I could have been Jean, Joan or Jane, all of which were acceptable translations of the very common Slavic name, Jana. They had picked Jane—the plainest, least interesting of the options, and the one used in the "Dick and Jane" children's primers. I'd like to say that in signing the poem Jana I had consciously begun a journey back to reclaiming my authentic self, but I was not that courageous. In truth, I was fearful of exposing myself and was looking for anonymity; a place to hide in case the poem was rejected. But it wasn't, and that created a whole new problem: how to share my pride in having become a published poet with my parents, especially when I

1944

Maminka- As-tu vu le poète à Terezin?

Pendant que tu faisais croître le jardin
Des enfants juifs dans un lieu protégé
Pour que la terre cède un espoir lointain
Que la pureté leur avait refusé

Pendant que mon père Agenouillé
Derrière la vitrine de la boucherie
Suivait le cortège d'un oeil paralysé
Théâtre vécu, mais un voile l'obscurcit.

(Lentement vers le dernier train fouettées
Femmes minces aux yeux verts, celles qu'il a aimées
Pleurent en silence l'enfance à Bucarest,
Montent, gémissant, pour disparaître à L'Est)

Desnos, moribond, parlait à côté
Chuchotant à l'ange du surréalisme
Fouillant des mots aux espaces du sommeil
Mots rêveurs qui sauvent ta vie, Judaïsme.

Ferme tes yeux verts, ma mère, et tu vois le monde changé.

Ecoute! Une symphonie de mitraillettes
Annonce les flammes pures du four crématoire.
Un parfum exquis remplit cette ville
Que devient l'odeur de la chair brûlante
De Ritta
Soeur à jamais inconnue

Viens vite, maman
Préviens papa qu'elle revit

Desnos l'a vue
Sortir des cendres.

Poem, "1944"
by Jana Z. Manson (1974)

had appropriated my father's most painful loss as my subject, and they had no idea I had done it. This is exactly how I typed the poem in 1971, with the French accent marks drawn in, because I did not have them on my typewriter.

I've never, before now, tried to translate my poem into English—it went straight from my gut into French, a bilious stream of consciousness. I was hiding everything from everyone in that language. And I wrote in a

1. What She Was Thinking

certain self-conscious, quasi-classical form: abab, abab, aabb, abab, which fell apart completely after three stanzas. I don't know if I just got tired of the discipline or I needed to lose the structure entirely in order for the rhythm of my words to reflect my erratic thoughts. I was studying French structuralism at the time. In English translation the poem has no form at all. In it, I address my mother. I ask her whether she saw the poet Desnos, in Terezín. I describe my father, standing mute, watching my grandmother Berta, uncomprehending, marching with the others in her transport toward the train to Auschwitz in October 1943. I describe the emaciated women with green eyes—my mother and I both have green eyes—climbing into the cattle cars. I use the French word for "lowing" to describe their moans. Throughout this, and while my mother tended a sad little garden that she told me she had built from nothing for the children in the ghetto, Desnos lies dying, whispering to the angel of Surrealism. In his fever dream, I see Ritta, sister forever unknown, being pushed into the flames of the crematorium. I say Desnos saw her, rising from the ashes.

I was afraid to let my parents see the poem, mostly because of the deep anger and cynicism I was feeling, and my fear that they would misunderstand my intentions. I didn't know until decades later when my mother wrote her life story for me, how attached she had been to the little garden that she planted for the children in Terezín:

"One day a young guy, who lived in our house and worked outside of the ghetto in the 'agriculture' group, brought me a small chestnut branch ready to bloom. It blossomed in a few days and to us, who hadn't seen anything growing for a long time, it seemed gorgeous. Not only people from our house came to the office to look at it, some even invited their friends.

"And then I had an idea. In the house we had about fifteen children of different ages, whose parents preferred to have them there and not in the so-called 'Kinderheim.' They were mostly in larger rooms, so that more children with their

mothers could live together (fathers were in another house). It was easier this way with less complaints.

"I thought that the kids might have forgotten in the last two years that something grows. I talked with the parents, asking them, if I could get the permission from a few of my bosses, if they would help me to make a small 'vegetable corner' for the kids in our big yard. They would have to bring the soil from some of the open spaces in the ghetto in boxes and we would plant it there. They were enthused about the idea. We didn't tell the kids until we knew that we could do it.

"Magdeburg Barracks (the Jewish Self Administration office) saw it as one of my harmless, crazy ideas and, within a week, the parents carried the soil in small and bigger boxes and containers and we had our flower bed. We found the sunniest spot…

"Nobody expected to grow vegetables there, but the green peas and potatoes started to come out and even bloomed. It was a big source of happiness for the kids and they took care by watering and proudly showing it off to anybody who was ready to look.

"Until September and October, when all of them went to Auschwitz to die.

"When I came back in 1945, and I went to Terezín to find out if by any chance somebody knew something about our family, the little, uncared-for flowerbed was still there. I remember I stood there and cried, maybe for the kids, maybe for myself or all of us."

My mother placed this anecdote as a postscript at the very end of her handwritten manuscript.

I wasn't supposed to know about, let alone write about, Ritta. When I broke the news to my parents that I had a published poem, and that it was about Terezín—about Ritta—they immediately insisted that I send it to them, and said they would have their Hungarian friend, Piri Ilko, translate it from the French. They never said a word about it to me

afterward. Not one word. And I was afraid to ask. But my mother ends her life story writing about their long silence:

> "So, we were waiting until Jana grew up enough to tell her and somehow let the time fly by. In the meantime, we tried to give her the best education so she could work her life out on her own. We were lucky. I understand now that with Jana, during her early childhood and growing up, not asking about details was out of fear of bringing out more painful memories and not that she wasn't interested.
>
> "You, Jana, proved it to us with your little French poem about Ritta, and your big interest in your roots and the result is my writing about myself.
>
> "I am now very happy, and since you remember your high school years and our move to San Diego yourself, I can say, now ending my story, with all my love, Mother"

She must have forgotten her own instruction that I must never, never mention Ritta.

"The green-eyed women from Bucharest": My mother had green eyes, as do I, and my mother had been born in Bucharest. As I wrote the poem about Ritta, I had been thinking about my mother only as a silent witness to my father's memories, not as someone who had survived as much horror as my father. I had not given her losses enough thought, because whatever and whoever she had lost, it seemed that for my father losing that child must have been worse. And that was what she had set up—she tried to protect him from his own memories. And she planted that in me. So, there was a long and deep silence about her own life. It was not until 1981, after the television series "Roots" and then the mini-series "Holocaust," that I asked my father to write his life story. I made a point of asking for his whole story, not just the war years. I was still afraid to broach it directly. I only asked my mother as an after-thought, when his

story was completed. But now I realize that wanting to know my mother's story went further back, and deeper in me, than I had imagined.

When I was living in Michigan in 1969–70, where my first husband Larry and I both had teaching jobs, I met Kathleen, another "faculty wife" stuck at home in a nondescript, conservative town, with a toddler about the same age as my son. We were the outcasts in that very constricted Midwestern society—women with yearnings for a life beyond the one we were living; yearnings that we couldn't even name. We entertained ourselves with afternoon trips to the local K-Mart to buy yarn for macramé projects. And we rebelled by smoking cigarettes every chance we got, choosing to believe that our disapproving husbands couldn't smell it on us when they got home from work.

Kathleen had entrusted me with the information that she had the ability to enter trance states, and channel the spirit world. Had the other faculty wives known, she might have been burned as a witch in that desolate town, but I was excited to hear the news. She went into a trance for me one day, while our babies were both napping, and reported that an image had come to her of a thin woman with green eyes on a crowded train, and that she "saw" the words "pear tree," despite the fact that there were no audible sounds from the other people in the scene. It seemed nonsensical.

When I called my parents in San Diego that Sunday, as I did every week, I told them about the mini-séance, and the images that Kathleen had transmitted. My mother immediately remembered that she had had an acquaintance named Mrs. Birnbaum (German, for pear tree), whom she had seen for the last time in late September 1944 on the transport from Terezín to Auschwitz, where everyone was mute with fear and dread.

This woman had not been a close friend of my mother, and she had no reason to think of her—it was then twenty-five years after the

war—but she told me that the picture of Mrs. Birnbaum on that train had come unexpectedly into her mind at practically the same moment as Kathleen had recited the scene to me, two thousand miles away. So I wondered whether Kathleen was truly channeling spirits from the "other side," or just the other side of country, in California. My father—always on the extension so they could both hear me and talk with me at the same time—quickly jumped in with, "Jano, don't worry about ghosts. Watch out for people. They are the ones that will hurt you." And that was the end of that discussion. I didn't think about it again until I sent my parents my surrealist poem several years later, and I included the line about the emaciated, green-eyed women—"les femmes minces aux yeux verts"—on the train.

But, again years later, and by chance, I learned that the foundational premise of my poem had been incorrect. The poet Desnos was not a Jew, and when I wrote my poem I was ignorant of the development of his thinking after the 1920s, when he was gallivanting with Breton and the other surrealists. By World War II, he had drifted away from surrealist poetry and word games, and he was arrested by the Gestapo for activities in support of the Resistance, which is how he came to die of typhus in Terezín, in the Little Fortress—the infamous Malá Pevnost, a place reserved for the torture of political prisoners. So it is doubtful that when he died he was seeking anything at all from the Angel of Surrealism, as I had so bitterly surmised.

Still, despite my youthful cynicism about the transformative power of art, in my own work in recent years I have taken my father and Ritta out of their historical circumstance—their fate—and placed them together in a mythical Zion, imagining that they had survived the war together. Ritta went up in smoke at Auschwitz in October 1944, with no poetry or symphonic accompaniment, and my father died forty years later in California, after dreaming every night that he was back in Auschwitz.

Josef and Ritta in the Promised Land (2015)
Digital collage on wood, 11 x 11 inches

His body had been liberated, but his heart and his soul stayed, and maybe died, with Ritta. The irony is not lost on me that if Ritta and her mother had survived, I would not have been born at all. That small detail brings me up short every time I'm forced to remember it and has made my own existence harder to justify.

Kde Domov Můj?
Where Is My Home?

"Prague does not let go — either of you or me. This little mother has claws. There is nothing to do but give in. We would have to set her on fire from both sides ... only thus could we free ourselves."
—Franz Kafka

To go back to the beginning and perhaps better explain my roots, I was born in Prague in November 1946. Franz Kafka was also born in the city, in 1883, another Jew in a city of Slavs, his destiny controled by Prussians—in his case, the Emperor Franz Josef II. As I write this, I wonder whether my father, Josef, born in 1898 as the youngest of eight children, owed his given name to the emperor. I doubt it. On the other hand, I doubt my grandfather Hynek (Ignatz) was thinking of the Biblical Joseph and his coat of many colors, either. My father had seven older siblings—Maria, Kamilla, Berta, Victor and Elsa, from an earlier marriage, and then his brothers, Otto and Karel. Grandfather Hynek was the head of the *Chevra Kadisha*, the Jewish burial society, in the little southern Bohemian town of Soběslav. In spite of this, he never managed to compel my father to learn Hebrew, so on his Bar Mitzvah in 1911, he read a transliterated script, which he unceremoniously laid on top of the holy Torah portion. The story he told me, laughing, about faking his way through his own Bar Mitzvah, did not appear in his life manuscript, but there he wrote:

"I never took religion seriously. Maybe because the
Gentiles did not take the Jews and Jewish religion as equal
to theirs, or because mother was so progressive and openly
a free thinker. In short, from my early childhood I never
believed. Consequently, I did not find it wrong, or against
the law, to avoid Jewish religion classes."

I can only trace my lineage on my father's side back as far as my
great-grandfather, Vitov (Jacob) Zimmer, born in the village of Přehorov
in 1825 and my great-grandmother Francesca, born close by in Tučapy in
1829. The men were peddlers, then storekeepers. My father wrote:

"At that time, Jews in the Austrian monarchy were
restricted by law to live in designated areas, like ghet-
tos, but they were allowed to do business also in the
district of their residence. My grandfather later rented
a little store in Soběslav and quit peddling. He walked
every morning from Přehorov to Soběslav and back every
night. Seven days a week. My father, Ignac (Hynek) Zimmer,
was born also in Přehorov on Feb. 23, 1855. ... In the
latter part of the nineteenth century, the Jewish restric-
tions were lifted, and my grandfather's family moved to
Soběslav."

I have always felt an affinity with Franz Kafka's novel, *The Trial*
and his novella, *The Metamorphosis*, because they seemed to presage all
the dark anxiety of the late twentieth century, mine included. When I
first read Kafka, I had not fully absorbed that he was Jewish, probably
because I was so focused at that time on my own need for belonging, to
escape from the unspoken, double trauma I felt as a daughter of Holocaust
survivors and refugees from communism. While Kafka himself had died
well before the Nazi era, his favorite younger sister, Ottla, I learned, was
deported to the concentration camp at Terezín (Theresienstadt), as my

whole family had been. On the 5th of October 1943, she was transported to Auschwitz and murdered. In this, too, Kafka's family history and my own converged: exactly a year following Ottla, on October 4, in 1944, my grandmother Elsa Kohn and my mother were taken on a transport from Terezín together. After selection at Auschwitz by Dr. Mengele, my grandmother was murdered. Like Ottla. I finally understand now why Kafka's melancholy, anxiety and outsiderness have always resonated so intensely in me. If I were to name my father—the grandson of an itinerant Jewish peddler, now, it would be after Josef K., and not a Hapsburg Emperor.

Many decades ago, on a visit to Paris, I was drawn to an exhibit at the Pompidou Centre, which crystallized the question: *Kafka: German, Czech or Jew*? At the time I thought the question was posed as though Kafka could choose. But now I see he has been defined by others, and history has taken the choice away from us. From me.

Still, based on their documents (see following page), my parents apparently did believe they had a choice, at least on paper. Even after the war, my mother and father each declared their preference in "nationality" in the same way as they had as before the Holocaust. In 1946, my mother chose to declare herself as Jewish, while my father chose Czech. Those primary "national" affiliations never changed. My father was a non-believer, an anti-Zionist and an assimilationist. My mother was assimilated, too, and secular, or at least she thought so until Hitler came and her neighbors pretended not to know her when they passed her in the street. But she had joined the Zionist Maccabi club as a teenager and had early dreams of going to settle in Palestine, as a pioneer. My father's post-war choice of Czech nationality was no surprise, since he had taken steps to formally "leave" the Jewish religion in 1939, weeks after Hitler came into Prague.

Identity card, June 6, 1946
One year after the liberation of Mauthausen,
and given a choice, at least on paper, my
mother Klara again declared herself to be
Jewish: "Zàpsanu nàrodnost: Židovskou."

Identity card, March 1946
My father again declared his Czech nationality:
"Českou."

Declaration: Leaving the Jewish religion,
Josef Zimmer, May 1939

Like so many other things, I wish I had seen this document when my father was still alive, so I could ask him about it. He had told me a story about having to "convert" back to Judaism after the war, so the chief rabbi of Prague would marry him to my mother. This alleged conversion included a session in the *mikvah,* or ritual bath. But I have not found anything from the Jewish community either documenting his departure

Birth Record, Josef Zimmer, January 6, 1898, Soběslav.

or his return. I do have his birth record from 1898, which even noted the name of the rabbi who performed the circumcision, or *bris*.

My engagement with visual art, which began long after my father's death, raised recurring questions similar to those confronted by Kafka. My parents chose Czech and Jewish, respectively, as their nationality in the country where they were born and in which their families were rooted, going back hundreds of years. The choice between Jewish or Czech for me, if I have ever had one, has been complicated by multiple separations: from Czech-born, to Canadian-raised to American citizenship, twice an immigrant who didn't quite fit anywhere, a child of Jews kept ignorant of the Jewish tradition.

But my confusion may also be partly rooted in my Slavic soul. It is no small irony that the title of the Czech national anthem, "Kde Domov Můj?" begins with the question: "Where is my home?" The anthem joyously answers the question, for most Czechs, but not for me. And the song itself has responded to historic changes. Written in the

nineteenth century to assert Czechoslovak national identity under the Austro-Hungarian Empire, the second verse, pertaining to Slovakia, was unceremoniously lopped off in 1992, when the country "split" peacefully into "Czechia," or the Czech Republic, and Slovakia.

My Czech-Jewish half-sister, Ritta, was not even seven years old when the Nazis marched into Prague in 1939, much too young to be aware of questions of national identity or belonging. But the restrictive measures and isolation of the Czech Jews began soon afterward, with their exclusion from public schools and other public places. Ritta was, however, childishly excited to sew the yellow star onto her jacket. My father wrote:

> "Jews were forbidden to frequent theatres, movies, restaurants, barber shop and food stores and they had to wear a Jewish star visibly on the left side of jacket or dress. When the stars were issued by the Jewish community and I brought them home, Ritta insisted on getting it sewn on her overcoat immediately and went out very excited and happy to show it to everybody. Poor child didn't know, and we didn't tell her the real purpose of the star."

Ritta was one of the child artists in the Terezin ghetto. There, she continued to draw pictures depicting the Czech flag even as she was imprisoned, I suppose because that is what children do when they are too young to fully understand their connection to these symbols of identity.

She imagined a child in a boat, waving a Czech flag. I wonder if she was escaping in that boat. Czechoslovakia was and is, of course, a land-locked country in the heart of Europe, notwithstanding Shakespeare's romantic reference to the "coasts of Bohemia." I can't guess the inspiration for the glasses, the urns, the tree, and the strange jungle creature. She couldn't have known that Neville Chamberlain, whose appeasement policy was one of the failings that doomed her, had described Hitler's

Marketa (Ritta) Zimmerova, Terezín
Drawing #131300
Courtesy Jewish Museum, Prague

demands for Czech territory as, "a quarrel in a faraway country between people of whom we know nothing." I've struggled to know something of this child through her images, and through her, to understand where I belong, with little success.

Kde domov můj? It wasn't strange to ask myself this question at the age of eighteen, or thirty-six or even fifty-four, but to still be asking, now, as I enter old age.... As in a mathematical Moebius strip, themes, imperatives, lessons and obsessions rooted in the phases of my life keep returning, through my artwork, disguised in different contexts. Things may be finished, but they are never over. Like history.

Impasse: A Collective Refusal of Memory

Schwer ist, a Yid zu sein. I don't speak Yiddish, which was disparaged by my mother as the lingua franca of the "Ostjuden"—nineteenth-century migrants from the garlic-infused shtetls of eastern Europe to cosmopolitan Vienna—but I understand this phrase. It means, in plain English, "It's hard to be a Jew." In the aftermath of the reciprocal rocket and bomb assaults between Israel and Hamas in May 2021, and the explosions of anti-Semitic rage in our streets, and around the world, I am questioning, yet again, where I stand, on Israel, and where I belong. Historical context and even facts are fluid, apparently, so I turn again to mining my parents' stories for their wisdom, and to review my own story, in relation to theirs.

I am fair-skinned, green-eyed, not in any way "Middle eastern" in appearance, but then, neither was Jesus, if you look at most of the depictions of him by western European artists. If I didn't use my hands when I talk—too loud, too insistent, too present—I might pass for white. I haven't felt the need to try, yet. My grandfather was a Kohn, so I have chosen to believe that, regardless of my ambivalence toward religious prescriptions, my genetic and historical connection to Palestine must go back to the Iron Age, at least.

In the Jewish biblical tradition, all Kohanim are direct descendants of Aharon, Moses's brother, the original Koh(e)n (Hebrew: כֹּהֵן, [ko' (h)en] "priest"). But my sense of genealogical entitlement is challenged, as soon as it arises in me, by the equally ancient tradition of the patrilineal line of succession, which holds that this special priestly status can only be transmitted through the males of the tribe. This is incongruous because, in folklore at least, the connection to *being* Jewish flows through the mother. I am only an old Jewish woman. Not as old as Sarah, when she birthed Isaac, but old. This gender problem, and the sense of simultaneously being blessed, and cursed, are among the many contradictions that have made it difficult for me to permanently fix an identity—or even a geographical location—for myself as a Jew in the world. This, and the fact that I do not fully belong anywhere as the only daughter of two Holocaust survivors, a refugee from Communism, and an immigrant twice over, myself.

I have never felt the pull of political Zionism. I was born less than two years before the founding of the "modern" Jewish state and raised with a vaguely comforting notion of Israel as a refuge for Jews, a place I have a Right of Return to, if necessary. My mother had been a Zionist as a young woman but gave up on the idea of emigrating when other Jews returned to Europe, in the late 1920s, disillusioned with the difficulty of the pioneer life in the inhospitable swamps and deserts of British Mandatory Palestine. Not to mention the murderous threat from Arabs—as they were then called, and called themselves—hell-bent on driving the Jews out of Palestine, beginning a hundred years ago.

No one—or hardly anyone but Jews with long memories—talks anymore about the Arab riots in Jaffa in 1921, or the massacre of sixty-seven Jews in Hebron in August 1929, and other places where returning Jews had lived on land that had been sold back to them—at market rates—by Arabs a century before. I don't mention these facts to

Why do some people have the power to remember, while others are asked to forget?

Power to Remember (2010)
Digital collage

justify anything or anyone now; I just feel despair that they have been erased entirely from the current narrative. *"Why do some people have the power to remember, while others are asked to forget?"* A Palestinian-American lawyer said this, but everyone who hears it, thinks it is about them.

My own mother gave this history little attention in her life manuscript, where she alludes to "very difficult times" for Palestine in the 1920s and 1930s. I don't know if she was aware that the alleged instigator of the 1929 anti-Zionist pogrom, Haj Amin al-Husseini, who had been arrested

and then pardoned by the British, was appointed Mufti of Jerusalem in 1921. He had gone into exile after the Jaffa riots of 1936, but he went on, in about 1941, to meet with the Nazis in Berlin to develop a scheme to eliminate the Jews from Palestine entirely, once the genocide in Europe was completed. Some historians have asserted that he was particularly close to Eichmann, and Himmler. It is undisputed that the Nazis had a special unit planned, called "Einsatzgruppe Ägypten," to exterminate the Palestinian Jews. The timing and extent of the Mufti's "suggestions," to his German hosts in Berlin, and of his involvement with the Nazis have both been vigorously debated, but there can be little doubt about his own endgame: expulsion or death to the Palestinian Jews.

My mother wrote:

"I have to mention now that (around 1926) when I was about 14-15, I started to drift more toward Zionism, my group of friends also changed. I preferred the company of older people and by that, I mean young adults, whom I found more interesting to listen to. I learned Hebrew and, had it not been for the very strong family ties, I might have given very serious thoughts to going to Palestine. I also had at that time a friend who, with her older brother, did go to live on a kibbutz; their parents were big Zionists and very enthusiastic about emigration. Absolutely not so in our family.

"However, both young people came back after a year, terribly disappointed and critical of the whole situation. That was around 1927, very difficult times for Palestine. I dropped my desire and thoughts of emigration right then and there, thinking that this way of life is not for everybody. Unfortunately, the years 1939-45 proved otherwise."

The years 1939–1945 proved otherwise. In March 1939, after the Nazis annexed the Sudetenland, Hitler's troops marched into Prague.

3. Impasse: A Collective Refusal of Memory

Hitler's demands for Czech territory had been viewed as unimportant—"a quarrel in a faraway country between people of whom we know nothing." Thus spoke Neville Chamberlain, as he capitulated, and set it all in motion.

My parents met and married soon after Liberation, in early 1946, each the sole survivor of their immediate family. They all had been deported, first to the Terezín ghetto, then to points east, to slave labor, or to death by the gas. My father lost his mother, his brother, his wife, his only child. My mother lost her mother, her only brother, and her husband. There were many, many more—cousins, uncles, aunts—all wiped out. I have the lists. But I am speaking here only of the nuclear core of the two families.

After the war, when they had barely settled into a new life together, with a new child—the repository of all their hopes for the future—the Communists took over Czechoslovakia in 1948, and my parents considered Palestine again. My father was on a business trip to New York when the coup occurred. My mother wrote:

"But in February of 1948 there were big changes in our government; the Communists took over and a small panic began. People with experience, who didn't want to join the party and were afraid of closed border crossings, looked for any reasonable route of escape. I promptly started going to different consulates and Jewish organizations but found out that the best that could be done for Jana and me, Daddy still being in New York, would be to join a transport of camp survivors in Poland, which went through Italy to enter Palestine illegally. I wouldn't be allowed to take anything with me, not even a handkerchief with an initial, because they were not sure under what name I would be traveling. It was understood that I could get off the train in Italy and eventually meet daddy there."

My father's reaction to this plan was negative:

```
"I spoke with Klara by phone, and she told me that
the only way she could get out would be with a transport of
Jews from Poland to Palestine. She could join the transport
illegally but only to Italy. No money, no baggage, without
any belongings and in Italy she would be on her own. Without
any money or visa to another country, even without a pass-
port with one-and-a-half-year-old Jana, we both said no. I
promised to be back in a day or two."
```

In June 1944, my father had been duped by the Germans into leaving his first wife and daughter behind in the Terezín Ghetto, to "volunteer" to build a "new family camp," where it was promised that Kitty and Ritta would be allowed to join him, and that conditions would be better. Fresh air. Food. The "new family camp" was in fact the Auschwitz death camp, where a few months later, Kitty and Ritta both were gassed. So, it is understandable that my father would not willingly agree to a separation from his new family. Apart from this, he was a confirmed anti-Zionist, and an atheist. He would not have gone to Israel of his own volition except as a desperate last resort, which it almost was. It took many months to secure a place of refuge, and to make clandestine arrangements to go. The Canadian visas came in May 1948 via my father's friend Vogel, in New York. No doubt money changed hands. Once again, the United States did not welcome us. We landed instead in Halifax, on the ironically named ship "Samaria," in the dead of winter 1948, about six months after the State of Israel had been declared to exist. To this day, I cannot stand not to know exactly where my passport is. I would like to have two, or more, just in case.

I was raised with my father's disdain for everything to do with religion and Zionism. He would never voluntarily set foot in a synagogue, let alone pay to join as a member, and my mother did not dare to do it

קרן קימת
לישראל

Early Tzedakah box, circa 1930

without him. On those rare occasions when I attended religious services or a social club at the synagogue with friends growing up in Montreal, I dutifully put coins in the blue collection box—donations I was assured would be used to plant trees in the "empty" desert of Palestine—without much thought to the politics of what that support represented.

We were shown pictures of the new trees. I felt I was doing good deeds. I was twelve.

In Montreal, we used to receive packages of Jaffa oranges from Israel. My only surviving cousin, Peter—who spent the first six months of his life as one of the youngest prisoners in Terezín—had been taken from our family home in Kroměříž, Moravia, to Haifa by his mother in 1949. I know for certain that packages were sent from us *to* Israel, because they—I was told—were living in greater hardship than we were as new immigrants in Montreal. Life was even harder there, my mother said.

I remember how sweet the oranges smelled. I had no idea until I went to Israel in 1995 where Jaffa was, what it represented, or that Jaffa oranges were evidently first cultivated in the nineteenth century by Palestinian Arab farmers. As a child, putting my coins in the donation box for Israel at the synagogue, I had been led to believe that all of Palestine, before 1948, had been an arid, empty wasteland, and it was not until the Zionists came that the desert began to bloom. This, like every other categorical statement, was only partly true. There are the thousand-year-old olive trees and the oranges to consider.

When Peter's wife, Hagar, died, I went to their house in Northern California to join him for the last day of the Shiva, the week-long mourning period. Peter brought out a beige jacket my mother had sent him when he was a teenager in Haifa. He told me he had been very proud of receiving a gift from Canada and he had kept it for over six decades. It was still in pristine condition. He had been told this gift had come from his Aunt "Klari," but he was never told, until two weeks before he came to California to study, as a twenty-year-old, that his father had died in Sachsenhausen, that he had been adopted, or how he was related to us. The silence about the Holocaust in his new family in Israel had been complete.

I don't remember thinking much about Israel as a young adult. I wasn't very interested in Peter's life in Israel. I never questioned why he was my only cousin. In college, I had deliberately moved away from

anything connected to Judaism. It didn't seem to matter to my parents. At nineteen, I had married an American. I was looking for security. I was eight months' pregnant in June of 1967, and feeling quite vulnerable, physically, when I heard on my car radio about the Arab attack on Israel. I think it was the first time I actively became afraid *as a Jew* of what might happen if the war were lost. Somehow my own safety was still tied up with what happened over there. I didn't share this fear with anyone, and it was not on my mind much for the twenty years after that.

My mother finally gave herself permission to visit Israel for the first and only time in 1985, the year after my father's death. She brought along my son, her only grandson, the trip a gift for his eighteenth birthday. When she returned, she described viewing the parades at the "Jewish" Olympics, choking back tears. *"It was beautiful to see so many Jews together, marching, and not to the gas."* My mother died peacefully and safely in her own bed in October 2000. She never knew her great-grandchildren, who were born three weeks before 9/11. They are twins: the boy was named Max for the compassionate American soldier who gave my mother a gift of chocolates when his unit liberated the Mauthausen concentration camp, in May of 1945. Max scoffs at religion, like my father did. His sister, Sophia, goes to synagogue to stand on the bimah and chant the prayers I still do not understand, on Rosh Hashanah. I go for Yizkor. My mother would have been so proud of them. But I can't dwell on what my mother missed. So much has happened since her death, to the world and to the Jews, that I am grateful she did not live to see.

My only trip to Israel occurred in 1995, the era of the Oslo Peace Accords, when I believed that peace and reconciliation were around the corner. We toured the Golan Heights, in what was billed as a "Peace Tour," with American journalists and academics—and I understood, viscerally, for the first time how it might have felt to be living in the valley below, in constant fear of being shelled by the Syrian army, before the Six Day

War in 1967. We drove through the West Bank to reach the kibbutz in the Golan. I am embarrassed to admit that until that trip, I hadn't understood that the "West Bank" I had read about referenced the bank of the Jordan River, and that Jerusalem was only a ten-minute drive from the Jordanian border, in a slow-moving tank. Two dimensional maps cannot tell the whole story.

Being physically present in that topography woke me up. I found myself taking sides. Was I a daughter of Zion, after all? But still, I was not a full convert to orthodoxy: I had compassion for the Israelis who had settled the Golan, they were the good, old fashioned labor Zionists. Real kibbutzniks, like my mother would have been. They had worked the land. We decided after a single day trip that they should have the right to stay. But I had contempt for the religiously inspired settlements elsewhere, in Gaza and in the West Bank. The Orthodox in general made me feel uncomfortable, and ashamed. I cringed at the sight of them. Who wears nineteenth-century black woolen coats and fur hats three times the size of their heads, in the desert? Who overpopulates the world with fourteen children who never learn anything but Torah, who live off the state, but never do any service, nothing to protect the country, their right to be there? One day, on a walk near the walls of the Old City, we asked some Haredim—ultra-Orthodox men—for directions. They were exceedingly friendly; they wanted us to stay and "learn" with them. I had a moment's fear that I was about to be abducted into a cult. I enjoyed the conversation, until we went to leave. I thanked them and put out my hand to shake theirs. They jumped back, instinctively. They cannot touch a woman not their wife. I was repulsed.

Despite the tears of identification that flowed as I stood before the Western Wall—relegated to the "women's side"—I knew I would never exercise my own "right of return." Even then, I could feel how soul crushing it must be to live in a constant state of alert, to not be able to

Ishmael and Isaac (2009)
Digital collage

breathe freely, to have to harden one's heart against compassion for the Other, to have to listen to prescriptions from people who had never been there, chanting simplistic demands, meaningless slogans.

But I had fallen in love with Jerusalem, despite my ambivalence about the treatment of the Palestinians in the occupied territories. I had known it was oppressive; it was the reason I had been too squeamish to

even consider visiting, before Rabin and the peace talks. And then he was assassinated by a right-wing Jew within months of our trip, a crushing blow. I found myself feeling hatred. For those Jews. After Rabin's death, the questions, my own discomfort, kept returning. Life went on, I had work to do, my grandchildren were growing. I put it all away. I hoped vaguely that a solution would be found, and that Jerusalem could be shared by the three Abrahamic religions. I wondered how many people know what the 1937 Peel Commission map looked like, which proposed the British retain control of the city. It also gave substantial land to the Palestinians. And I wonder if there are any regrets in the Arab world for having rejected the next version of the map made in 1947 by the U.N.

These warring maps remind me that Holocaust denial began almost simultaneously with the establishment of Israel, when the Arab States objected, in 1952, to the first German reparations programs. They wanted that money to be paid to Palestinians who had been dispossessed in the 1948 war. That would have been a good idea, but the other European colonizers who carved up the Middle East in the nineteenth century also had responsibility. Still, the Arabs shouldn't have worried that the survivors might get rich. My parents never saw a penny in reparations payments until 1971. My mother, who applied, was required to prove a mental disability directly connected to her experience in the camps and the German psychiatrists didn't believe her. At one point they classified my mother's trauma at "only" 23 percent disabled, when the threshold was 25 percent, or some such ridiculous number. The small payment they finally did receive did nothing to relieve my father of the nightly dreams, for forty years until his death, that he was back in Auschwitz.

I went along vaguely hoping for a change for the better for about fifteen years after our visit. Things shifted inside me again, in January 2009 when I read an op-ed piece in the *Los Angeles Times* written by the propaganda minister of Hamas. It stated: *"Without debating here the*

3. Impasse: A Collective Refusal of Memory

fictive, existential right of the Zionist state, which Israel, precisely, would the West have us recognize? ... Is it the Israel that illegally settles its citizens on other peoples' land, seizes water sources and uproots olive trees? ..." In response, I made the body of artwork I called "Impasse."

"*Fictive, existential right...*"?

Something insidious in the sentence structure made me feel like I was being waterboarded. Unable to breathe, unable to find words, other than, "No, No, NO!" I began to make digital collages, using my original monotypes as backgrounds, and incorporating historical maps, text from newspaper articles, and altered family photographs—in particular, a childhood photo of my uncle Fritz holding a toy gun, circa 1916, and a record of his arrival in Bergen-Belsen on February 14, 1945.

By putting Fritz into work about Palestine, I think I was trying to pull his memory and his spirit out of his miserable final months in Bergen-Belsen and Sachsenhausen. Or it could have been simply the fact that his face represented a generic child of Semitic origin, which could have been Arab just as easily as Jew. Ishmael and Isaac.

I wrote in the gallery notes about the "Impasse" exhibit: "...our inherited memory of the founding of the State of Israel ignores some inconvenient facts about those other Semites then unhappily sharing the land with the Palestinian Jews. Yet, the stories of those advocating for Palestinian statehood and a right to return, despite their relative nearness in time to the shock of dispossession, are not dissimilar in their essential elements from the Jewish story throughout history. In the end, there are harsh truths to be faced on *both* sides of this conflict, and perhaps the greatest obstacle to moving forward is the fact that the political agenda of each people depends on continuing to deny the narrative, experience, trauma and memory of the Other. This work suggests some of the ways this denial manifests. How to create acceptance is another project."

For my part, I have had to adjust my beliefs to accept that Jews as well as Palestinians have trampled history, and the landscape, and have killed the other's children.

I later placed the oversized, ambiguously Semitic boy, dominating the three-thousand-year-old olive trees revered by the Palestinians, in a landscape vertically divided, and underscored by my father's quote: "Nobody knows when his time will come." A version of this image of Fritz was exhibited in the Jerusalem Biennale in 2015. I was somewhat anxious about how this piece would be received, and I was surprised that there appeared to be less hostility to critical thinking about Israel, in Israel, than in the United States a decade ago. At least I did not get the sense that there was any interest in censoring artwork. The title, "A Land with No People, for a People with No Land," is a quote misattributed to Golda Meir. It did reflect the belief system that I was given as a child, and that I was shocked to learn, as an adult, had been quite untethered from facts on the ground, as the Israeli settlers like to say.

Like everything else, my relationship to the "promised land" continues to change. In the last ten years I have had to accept that the politics of the Israel we know today continues to be unduly influenced not by progressive thinkers, like my mother, but by eighteenth-century religious fanatics, bearded men in black hats. It does not reflect the aspirations she had for the nation born in 1948. Nor is this the Israel that is represented in the anthem I sang at a Jewish summer camp, in the Laurentians, when I was twelve. Even though I had to lip sync the words in Hebrew, the melody, "Hatikvah" ("The Hope"), brought feelings of pride, and tears to my eyes. And then I am reminded that this melody, which continues to move me, was likely based on the Czech composer, Bedřich Smetana's set of six symphonic poems celebrating Bohemia, "Má Vlast" ("My Homeland"). So I don't even know if my tears are Czech tears, or

3. Impasse: A Collective Refusal of Memory

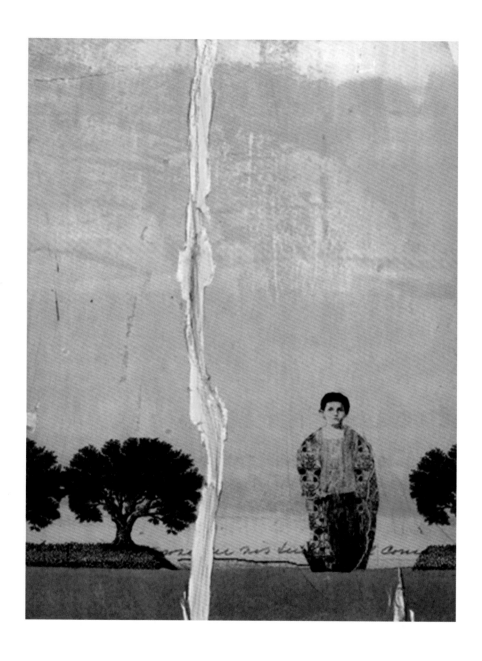

A Land with No People for
a People with No Land (Big Jew) (2015)
Collage on wood, 11 x 11 inches

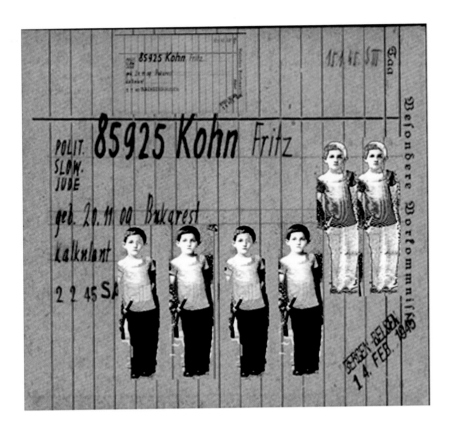

Fritz, Prisoner #85925 (2010)
Digital collage

Jewish tears. It is no small wonder that I have remained confused about where my loyalties reside. But I see that I don't get to choose them; they choose me, or are chosen for me, when the world reduces my genetic attachments and generational trauma to slogans.

What I do know is that every received idea is up for debate. George Bisharat, a Palestinian-American lawyer wrote, "[T]he hyper-emphasis of the pastoral connections of Palestinians to the land is reflective not of

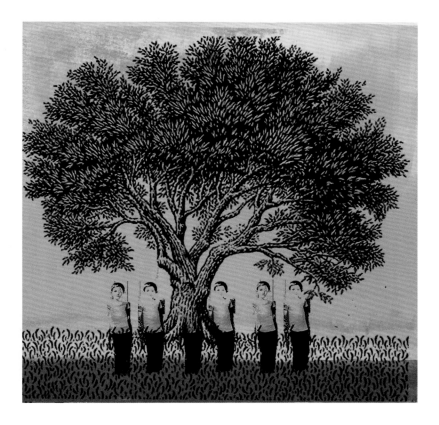

Our Olive Tree (2010)
Digital collage

genuine rootedness, but of an intellectualized, stylized assertion of place under conditions of rupture and threat." It seems to me that the history of political, emotional and religious Zionism is similar—born under two *millennia* of conditions of rupture and threat. And the "fictive, existential right" that the Hamas propagandist sneered at, can be attributed to Palestinian Arabs, just as easily as to Palestinian Jews. Either both peoples are connected to the land, or neither is.

What makes the struggle even more complex, and intractable, now, is an additional layer of religious attachment to that well in Jerusalem. And to the location of the Dome of the Rock. The trauma of memory prevails. But whose memory? The diasporic Jew, the rootless wanderer? Or the Brooklyn Hasid who *does,* apparently, believe that his roots lie at the bottom of a well in Jerusalem. Do those roots, historical, genetic, religious, no matter how long ago they were forcibly cut, give the Jew status as an indigenous person just as the (relatively) newly named Palestinian people now claim that status? And do we all have the right to return, no matter how many years have passed, to the home our souls and memories may seek?

What is most painful to me, at this late stage of my life, for my own sake as well as for my Jewish grandchildren, however much they see their Jewishness as a choice, is that just as overt acts of Jew-hatred have multiplied around the world, Jews have been increasingly isolated, excluded, as unworthy of partnership in the common struggle for a more just and equitable world. Jews are being systematically shunned by advocates of intersectionality. This is extremely dangerous, and I am frustrated that people who I used to believe were allies cannot bring themselves to dig into history deeply enough to understand why. When I visited the Jewish Museum in Melbourne recently, I found a letter from the Australian Aborigines' League to the German consul in 1938, protesting the treatment of the Jews by the Nazis. It brought me to tears.

R E S O L U T I O N.

AUSTRALIAN ABORIGINES' LEAGUE

5th December 1938

TO: THE HON. CONSUL Dr. R. W. Drechsler.

GERMAN CONSULATE 419 COLLINS STREET MELBOURNE

We the undersigned, on behalf of the the Aboriginal
Inhabitants of Australia, wish to have it registered
and on record that-
"We protest wholeheartedly at the cruel persecution
of the Jewish people by Nazi Government in Germany.

We plead that you would make it known to your
government, and its military leaders, that this cruel
persecution of their fellow citizens must be brought
to an end".

We respectfully request that you accept this resolution
and we look forward to news of an immediate end to
these atrocities.

Yours,

the undersigned...

SIGNATURES OF OFFICERS ADDRESSES

(This document is a construct & digital creation and not the original document)

Resolution of the Australian Aboriginal League
1938

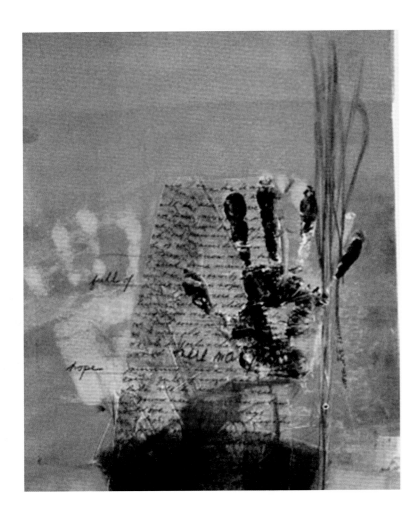

Full of Hope / No Hope (2007)
Monotype, 11 x 14 inches

When Daddy Died

My father would have been one hundred and twenty-three years old on January 6, 2021. He has the same birthday as my maternal grandmother, Elsa. It is no small irony that January 6 will now be remembered as the date of a failed fascist insurrection in the United States, a day that will live in infamy, if it is properly remembered.

It is strange that, of all things, I can never quite remember the exact date of my parents' deaths. I wonder whether this might be because we cannot know, for certain, the exact date of death of the majority of my parents' generation—only deportation dates and transport numbers. There was no tradition at home of observing a specific day to say Kaddish, the Mourner's prayer. And the prayer should traditionally be recited in a minyan, or communally, at the synagogue, a place we never went. And because the lunisolar Hebrew calendar dictates a different date to remember every year, I gave up keeping the ritual of marking my parents' deaths according to tradition altogether. I still light a memorial "Yahrzeit" candle for them on their birthdays, and most years I go to visit them at the cemetery during the High Holy Days, between Rosh Hashanah and Yom Kippur, which is the one custom my mother taught me.

My parents' ashes are together now in the cool shade of an old

cedar tree at the top of the hill in the seaside Santa Barbara cemetery, among the oldest graves. "The best neighborhood," my mother and I joked, when we bought the plot. She was happy that we had moved my father from his dreary, graffiti-covered graveyard in East San Diego when she came to live with us. They would both finally have an ocean view, she said. "Daddy will like that," we agreed.

I had vaguely remembered that my father's death was around the time of the ancient Roman Ides of March, and when I checked the death certificate, I found confirmation that it was March 12. The Romans considered the Ides on the fifteenth to be the last date for settlement of debts, so it is not surprising that when my father was put on morphine for his final five days on Earth, he called for the family checkbook so he could pay the month's bills before he went. He knew he was dying, although no one around him would say it out loud. I noticed for the first time, too, on the death certificate, that his occupation was listed as "Retailer – Knitting goods." This was accurate, as that was his last known occupation, but it isn't how I would have summed him up. I wonder if my mother was made to choose an occupation from a list. Still, it was not so different a label, in the end, from my great-grandfather Vitek (Jacob) Zimmer who, with the dispensation of the Emperor Franz Josef II himself, came in from the cold of itinerant peddling in the late 1800s to establish a dry goods store in Bohemia.

My father had been an executive with a national refrigeration company in Prague before the war. When the Gestapo arrived in 1939, they picked him up from his office to have him "consult" on the installation of a new refrigerator system at their headquarters. They never figured out he was a Jew, or chose to ignore it, and gave him the *Sieg Heil* salute at the end of the appointment. He had nerves of steel, before Auschwitz.

4. When Daddy Died

He wrote, in his Czech-inflected sentence structure:

"There was at the curb the usual black Mercedes convertible with the swastika banners on both front fenders. I took a seat next to the driver and the Gestapo officers in the back. The warehouse was part of a huge freight railway complex on the other side of town. I was nervous and hoped nobody will see me. When we came to the gate of the complex, there was standing and looking at me in shock, my customer and friend Roubiček, owner of a poultry and dairy product business. I didn't look at him, but he was staring at me. They chose two large boxes. I promised the delivery in two days. They said, 'We take you back to your office.' I refused with thanks that I want to make sure the boxes are in perfect working order and wanted to arrange the delivery. They thanked me, shook hands with me and to my surprise, stood to attention, raised their hands in Nazi salute complete with Heil Hitler. I was stunned and after they left, I sat down and didn't know should I laugh or worry. If they should find out, many things could happen, none of them good. When I was leaving, Roubiček still stood at the gate waiting. When he saw me he ran to me with questions. He thought I got arrested and would be shipped to a concentration camp. I laughed and told him, 'You are talking to the only Jew in the world who was saluted by the Gestapo with *Heil Hitler*.'"

His experience with refrigeration systems also saved his family from hunger in the Terezín ghetto. He had thirteen relatives who had been deported there, for whom he took responsibility. He was the sole survivor.

"Everybody in the ghetto who worked with food or had any connections to it was, and his family was, saved from hunger. For a time being there was only one butcher shop which was under ghetto management.

"I had to take care of six refrigeration units. That didn't take too much of my time and I spent most of my time working with the butchers. The meat delivered to the ghetto was of substandard quality classified by veterinarians as unfit for human consumption. Farmers and butchers from sur-rounding places brought this material to the ghetto with gendarmes as escort. The meat was taken over by the ghetto butcher shop and stored in coolers. Once a week the kitchens picked up their rations, three decagrams per person, about 1 ounce. Twice a month we made salami or sausages. Again, three decagrams per person. The allowed loss by drying was three percent. If there was an epidemic and a great number of animals had to be killed, we had so much meat that all coolers were overstocked. I don't think anyone kept a record of how much meat is in the cooler at a given time. The Gestapo disregarded all reports that the coolers were overstuffed and that there is a danger that the meat will spoil, and they didn't allow to increase the rations of three deca per person. Everybody in the butcher shop found a way how to decrease this dangerous overstock.

"Actually, meat stolen in the butcher shop was not stolen from the ghetto inmates, it was taken from the Germans. No matter how much everybody stole, nobody had a bad con-science that he stole from the tiny rations of his fellow Jews. It was a different story if the kitchen personnel stole from the meat they have received to distribute to the Jews. That meat belonged already to the ghetto inmates."

This anecdote about ghetto ethics impressed me. My father always drew clear lines, even in that extreme situation. My mother also reported that in general, the Jews in the ghetto did not steal from one another, nor was there any significant violent behavior among them.

After the war, and before we emigrated, my father resumed his previous position as an executive with the national refrigeration corpora-tion. I still keep his business card taped to the worktable in my art studio. The awkward translation of the name of the corporation amuses me.

4. When Daddy Died

PHONES: 615-73, 625-15
CABLE: ŽIVNOSTROJ, PRAGUE

JOSEF ZIMMER
MANAGER
OF CENTRAL SALES-OFFICE
OF REFRIGERATING & FOOD-INDUSTRY MACHINERY
NATIONAL CORPORATION

OFFICE:
TRUHLÁŘSKÁ 16, PRAGUE II. CZECHOSLOVAKIA

Josef Zimmer Business Card
1948

When we first arrived in Montreal from Prague in December 1948, my father initially found work selling dishes door to door in the dead of winter, and later got a job as a refrigerator repairman. He was fired from that job on Christmas Eve, and came home and told my mother,

"Today you could be happy that you are Jewish. Can you imagine how depressing it would be if you were a Christian and I got fired on Christmas?"

After a couple of years, he started to work for the Von Bochs, of Villeroy & Boch, and built a showroom for their dishes and floor and wall tile. When he decided to retire to California in 1963, the Von Bochs bought out his contract, even though he was the one who wanted to leave. We always thought they were generous with him because they knew he was a survivor, but I don't think they spoke of it together.

I still have a set of their plates, from that era. I also have the Seder plate that Villeroy & Boch manufactured in a limited edition to commemorate the Precious Legacy exhibition at the Prague Jewish Museum in 1986.

This was the last, and probably the longest conversation my father and I ever had.

```
Dialogue between Father (F) and Daughter (D), he on his
deathbed, March 1984.

F: I am weak.
D: You are tired, you should try to sleep.
F: I have to go through something first. I am afraid this is
too much for mother.
D: Don't worry I will take care of mother.
F: Thank you. Where is mother?
D: She went down to repark the car.
F: What difference does it make?

— March 12, 1984. Retrieved from the back of a drawer,
December 2019
```

"I am weak," he began. He was short in stature, like the infamous Vietnam era war criminal, Lt. William Calley. My father had volunteered this comparison, he said, wanting to explain that he understood the feelings of male inadequacy that might have led Calley to participate in the massacre at My Lai. But my father did not suffer from that dis-ease with his physical stature, or if he did, it never showed. He was steely strong. He had always been steady, upright, indomitable. He carried his full five-feet, five-inches ramrod straight, befitting his training as a reluctant conscript in the Austro-Hungarian Imperial Army, circa 1916. He never showed fear, not in front of me, except

once, in San Diego in the 1960s when the sheriff came to the door at eleven o'clock at night to serve him with court papers. A civil suit, initiated by a crooked business partner, so why the late night-time service of process, why the gun? He took the papers and after the lawman left without shooting him, he sat on the couch trembling, as though he had been served with a deportation order. "Nobody knew when his time will come."

In 1965 Los Angeles, when fires were consuming the largely Black neighborhood of Watts after a hostile police confrontation with a resident, I walked into the den to see the TV news of the destruction and violence. The L.A. police chief compared Watts rioters to "monkeys in a zoo." My father was rubbing his forearm, where the tattoo was: B11828. B for Birkenau. He looked up and said, "I understand why they are doing it. When you are treated like an animal, you begin to behave like one." Although conditions in Watts were deplorable, they were light years from the misery of Terezín ghetto and the death camps, and I was struck by my father's capacity for empathy, while so many reacted from a place of fear and hostility.

He never talked about his feelings, or even his state of health. All reports on that front came from my mother, who mediated between us, and spoke the truth she wanted to believe. Never, not once, did he say he was sad. Never once did I see him cry. Well, once. I didn't actually see the tears because he cleared his throat and quickly left the room after giving me the picture of my half-sister, Ritta. He had just read the poem I wrote about her and came in just as I was preparing to leave. He looked at me and said,

"That poem you wrote..."

"Yes?"

"You wrote about your sister."

"Yes."

"Do you want a picture of her?"

"Yes."

He didn't hear my choked, "Thank you." My throat had also closed. I couldn't let him see my tears either, because I was afraid it would make him even sadder. This conversation occurred about ten years after I had sent them the poem. It was the first and only one.

Our family visit to the Terezín ghetto in 1971, was the first of four visits, for me, over a period of forty years. I was with my first husband and our son, Geoff. We had been in Prague for my parents' twenty-fifth wedding anniversary, which they chose to celebrate with their first visit "home" after fleeing to Canada in 1948. We had brought along one of my father's survivor friends, Karel Stern, and his girls, Marcela and Simona, who were in their teens. We made the ghetto visit a Sunday outing to the countryside, in our new, blue-and-white VW bus, which he had consented to travel in, despite his vow never to climb into a German car. "I want to show Janie (me) my condo," he had said, laughing, as Karel laughed uproariously along with him. They marched us through the ghetto to find the attic which he'd fixed up for himself, his wife, Kitty, and ten-year-old Ritta, so she wouldn't have to live separately in the children's barracks.

Later, still in the ghetto, in a café immediately next door to what had been Eichmann's office, we had my favorite lunch, *knedliky s veyci*—leftover Czech bread dumplings cut up and fried and scrambled with eggs. As we ate, he and Karel continued their boisterous camp stories, accompanied by belly laughs as I sat in a horrified silence. Once we were back in Prague, another survivor friend asked him, "So, what did Jana think of Terezín?" My father, misinterpreting my silence as indifference, and without even looking at me, said, "They don't know. They can't understand." I wanted to disappear, but I said nothing.

4. When Daddy Died

With this history of silence, his simple dying declaration, "I am weak" was an acknowledgment that I should prepare myself, that it was almost over. I didn't tell him he would feel better. I just told him to try to sleep. My mother and I stayed in the room with him those last days and nights—she on a cot beside him, me in the chair next to the bed, my bare foot outstretched so he could touch it or hold on to it, if he wanted to.

"We keep fighting," my mother had said. It didn't help that the doctor told us virtually nothing. "Things should clarify by Sunday," he said, before going on vacation. And my mother never questioned this. But on that last night (the Sunday the doctor had mentioned) as I prepared to leave her at the hospital to go back to her house to sleep, she asked me to stay, and she went to repark the car before returning to fall straight into a deep sleep on the cot next to his bed.

So, I was left alone with him to complete our little dialogue. "*I have to go through something first,*" he'd said. I told him to rest. I wanted him to let go, so I could let go. I couldn't stand the idea of him suffering, or of losing him. He was so much older than all the other parents—forty-eight when I was born—that I was always afraid that this time would come too soon. Now I wanted to get it over with. My parents had always looked as old as the grandparents of my friends. As a little girl I had once asked him how long he thought he would live. Seventy, he thought. That seemed old enough at the time that I told myself that by the time he died I would be able to manage without him. He got to eighty-six and of course I wasn't ready. Even though he was an atheist all his life, he still had something he needed to do before he died, other than pay the bills. There was something else to settle up. I wish I knew what was on his mind, so I would know how to do it myself before my time comes.

Then he said, "*I am afraid this is too much for Mother.*" That was the essence of their marriage. A marriage of convenience, in a way. They had each made a choice to go on, after the war, but knew that only a few

in the world could understand them. Their marriage was conducted in a silent understanding, and in complete devotion, one to the other. Each thought of the other, first. Always.

His last words to me were, "*Thank you.*" For my promise to take care of Mother. Even though she had exasperated him at the end, by leaving his bedside during his last fully conscious moments to go repark the car. I remember her looking out the hospital window and seeing it there, several stories below, not exactly parallel to the lines of the parking space. Not over the lines, not dangerous to anyone else, but not exactly parallel. So, it had to be moved.

He was always waiting for her to straighten things out to her satisfaction. Waiting outside, in the car, before their Sunday excursions to Shelter Island, while she perfected the appearance of the house, so that it would be in order when she returned. "*What difference does it make?*" he'd bark. She just couldn't stand to see him go, so she missed the chance to say goodbye. He stopped breathing within moments of her falling asleep. He exhaled, and it took more than a moment for me to understand that he was not going to inhale ever again.

All this remembering feeds my mania for detail. Such attention to detail saved my mother's life in Freiberg, and my father's on numerous occasions. So, now, for accuracy, I look for a Hebrew calendar calculator for 1984 and find that my father died on the seventh of the month of Av; the same date as both the birth and the death, on his 120th birthday, of Moses. I also see that the *Chevrah Kadisha* (Jewish Burial Societies) hold their annual get-together and feast on Adar 7th. This is based on the tradition that God Himself buried Moses on this day—granting them a respite from their labors.

I got no such respite from my duties. Although we arrived back at my parents' house at three a.m., where I fell into a deep, dreamless sleep, my mother was up before six, rummaging in the closet. An hour later she

4. When Daddy Died

came into my room—the room that had been mine when I was in college —with directions for calling the local Jewish mortuary. I had been awake already, listening to the scraping of metal hangers along the wooden rail next door, as she organized and reorganized my father's clothes.

He was cremated, then buried according to Jewish custom on March 14. The four roses on his box of ashes were from me, his only grandson, Geoff, from my husband, Richard, and my mother.

March 14,1984

The cemetery
The only place there is no sadness.
There is no sign of you, there.

That eighteen-inch square hole
The copper box of ashes
The four roses laid on top.
You were never there.

On that morning it rained
A steady, late winter drizzle, the first dampness,
The first clouds in weeks.

You are so present in your absence,
So gone from the remnants of your time here:
Your steady voice on a tape, recording your life story,
Recited from your own meticulous handwriting, in mono
 tone, word for word,

Nothing left to chance.
Your European hand-knotted carpets
The one you started after your eightieth birthday—the 80,000
 knots you calculated it would hold.

7th Adar 5744 (2021)
Digital collage

"Not a project for an old man," you said, laughing, but you
 finished it.
I kept it as long as I could.

You were in those knots, and in the interstices of the wood,
The creaking planks of the bed you built for us.
As the last breath left your body, an exhalation so quiet I
 did not know it was the last,
It entered these things you left me.

Beginning Art

Within a year of my father's death in 1984, I blew my life up. I left my second marriage, my house, my job, and damaged my relationships with my mother and my son by becoming involved with a man I thought would take care of me, like my father had. He didn't. I am leaving aside, for the moment, the irony that even my father had not taken care of me—emotionally—the way that I was led to believe he had. I do not remember speaking or writing about my father from his death in 1984 until 1995, when I opened the box I had put my feelings into, by making another box that I allowed to be open, and to look inside.

I had been invited to contribute an artwork for Women Beyond Borders, an international feminist art project. For my piece—an assemblage—I glued a picture of myself as a child on the top of the open box and bound it with straps to the contents. Inside, glued to the bottom, I hid a photo of Ritta and Daddy, from about 1935.

I could have done absolutely anything with that box. I had complete freedom to express whatever it was I wanted. I don't recall thinking about it very long before I went ahead. By putting my father and Ritta

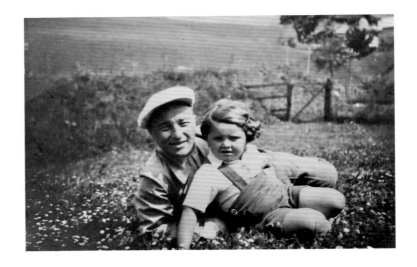

Ritta and Daddy, 1935

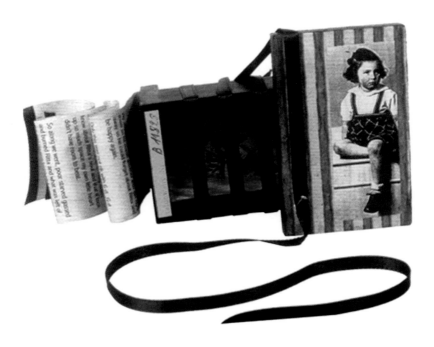

"For Ritta" Assemblage (1995)
Wooden box, collage, ribbon, 4 x 5 x 2.5 inches
Gift to Women Beyond Borders

inside, I protected them from all but the most persistent eyes, and then I wrapped the box in black ribbon. I consciously made it look like the leather straps that affix the tefillin, or leather boxes containing Hebrew prayer scrolls, to the body. I can say with certainty that my father never did this. He thought Judaism was a primitive religion. All religion was considered primitive.

The picture of myself as a little girl that I affixed to the top of the box showed me in a green knitted skirt that my mother had made for me, on a background of gray stripes—a cheap reference to the camps, but it worked well with the black ribbon. As an afterthought, I attached my own scroll, an automatic writing that I had done about twenty years before. Attaching it was a way of saying things without exposing them. I felt embarrassed because this piece had been written in an ugly scrawl with my non-dominant hand, and I found myself speaking in my little girl's voice. I did not mean for anyone to be able to read the scroll. It was still my secret, representing my innermost thoughts, those I hadn't even known were in me. I suppose it was another version of writing a poem addressed to my mother in French, a language I knew my parents did not understand. Once again, I was hiding my feelings in plain sight.

Lorraine Serena, the artist who created Women Beyond Borders, inadvertently took the choice of self-disclosure out of my hands by publishing the full text of that scroll in the catalogue for the exhibit. It still makes me cry to read it. It is/was the deepest secret. It was how I understood my place in the world, it was sad, and it shamed me and made me feel crazy all at once.

My sister died before I was a little girl.
She was put in a gas chamber in a
concentration camp.

My daddy was so sad he couldn't stop them
So he made another little girl right
away so he could forget about Ritta and
be happy again.

Only this was not ok with G-d. G-d
thought that this was too fast, so he
played a trick on Daddy. He took
Ritta's soul, which was still very upset
from being starved and gassed and
burned and sent it back to Earth.

Normally a soul would be allowed to
float around out there for a couple
hundred years or more to calm down
after doing Life. So, it was shocking for
Ritta's soul to come back too quickly
and — this was the mean part — to be
stuck in Janicka's body.

This was very hard for me. I thought I
was supposed to smile. Everyone
wanted me to be a happy, pretty little girl
so they could be happy and forget. But,
too bad I looked like a bullfrog and I
could tell they thought that and were
ashamed. So, no smiles. They didn't
know about Ritta's soul and that it took
up so much space my own little heart
didn't have room to beat.

So along we went, poor starved gassed
and burned Ritta, and what was left of
me, and no one knew so I was very sad
and lonely.

5. Beginning Art

And poor Daddy couldn't
forget Ritta because she was inside the
little bullfrog.

—J.Z. Automatic Writing, 1979

In 2020, I cleaned out my shed, and found the forest painting that I had grown up with (see page 36). I first started to be afraid of this painting as a child after I asked my father why he had the blue numbers on his arm. I can't conjure up a setting, so I don't know how young I was, but I feel sure we were in the room with the painting. He responded, "Some bad men put me in jail." I asked, "What did you do wrong?" He said, "Nothing. They were bad men." I think I was always afraid those men would come out of the dark forest for me. I always respected that, at least when I was a child, he didn't try to turn me against the Germans.

I know my father had nightmares. He told me, the year before he died, "Every day I live a normal life. In the daytime, I am an American, an American citizen. I am safe here. But every night when I go to sleep, in my dreams I am back in Auschwitz."

That statement affected me profoundly. I will never comprehend how he carried this, how he carried on a normal daytime existence. He had no tics, or tantrums, he was not verbally or physically abusive, to anyone. He occasionally lost patience with my mother's endless organizing and bellowed, "Klaro!", but these were one-note exclamations of frustration, and typical of Czech men of his generation, as all my friends' fathers bellowed in Montreal. But they must have frightened me. I still cannot stand to hear men explode in anger, even without a threat of imminent violence. He didn't talk about his memories, and he didn't cry, except for that one day when he gave me the picture of Ritta. He carried all that pain for all those years, until that final exhalation of breath.

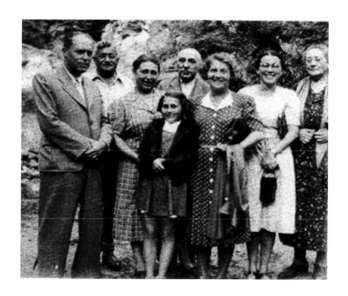

Family Löff, Kroměříž, 1938

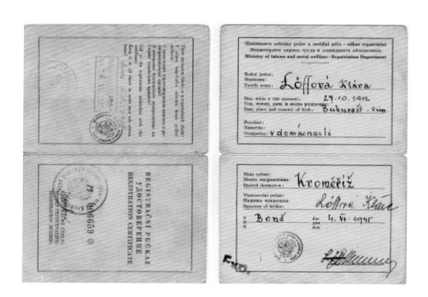

Repatriation document
Klara Löffova, May 1945

The Terezín Series (1995-2007)

About eleven years after my father died my mother came to live with me and my husband, Richard, in Santa Barbara. I had promised her that she would never go into a retirement or nursing facility. "I won't go in a *Heim*," she had said. I abhorred the idea that she should end her life in an institutional setting, having survived four concentration camps.

Soon after she arrived, a friend gave me a book about the American painter and graphic artist Robert Rauschenberg, and I began to take classes in collage and printmaking. My first primitive attempts to memorialize my mother's family began with digital collage and monotype.

My mother had attached a note with a paperclip to this photo of her family, indicating that she had been the sole survivor of the family. Her husband, Alfred is on the left, my grandmother Elsa, on the right. My mom is next to her.

After Lorraine Serena took my first assemblage box, "Daddy and Ritta," into the Women Beyond Borders project for their traveling exhibit, I was inspired to do another, which focused on my mother's experience. I had read a book about the Balkan wars in the early 1990s and called this box "Balkan Shoe." This time I put the entire box into

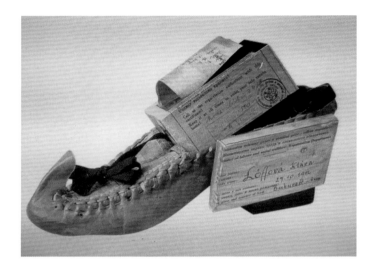

Balkan Shoe Assemblage (1995)
Wooden box, collage, 4 x 5 x 2.5 inches
Gift to Women Beyond Borders

a traditional Balkan folkdance shoe, collaging my mother's repatriation documents after liberation from Mauthausen to the lid.

On one occasion, soon after she moved in with us, I took my mother to a lecture in town about the use of art therapy in nursing homes in England. Part of the program involved asking the elderly attendees to trace an outline of their hand, as children learned to do, and paint it with watercolors. The idea was to bring up and resolve memories of trauma. My mother was reluctant at first, because she was already legally blind, and had always been self-conscious about her lack of artistic ability, but she did try it.

I traced my own hand and mixed the colors incorrectly so that it appeared as a brown glove. My mother's hand was pink as the dawn. On the way home, she said, conspiratorially, "I have something to tell you about the hand painting."

My Mother's Hand (2021)
Digital collage

"What?" I asked.

"The brown color that you painted your hand reminded me of the color of the glove of the SS guard who hit me, in Freiberg. We were being walked back to the barracks from the factory, and we saw the whole sky was bright pink and red. We knew that the British or the Americans must finally be bombing Dresden. I turned to my friend, Hedy, and said, 'This is what we have been waiting for.' I didn't know it, but the guard walking with us was a Sudeten German who understood Czech, and when he heard this, he hit me so hard I fell down to the ground. But I said to myself, never mind. Now I know that I will survive, because the end of the war is coming."

My mother was with us for five and a half years and died peacefully in her own bed, as I had promised her. I played the Czech film, *Kolya* for her on that last night in October 2000. She was in a morphine-induced sleep, but I wanted her to hear the music of Dvořak, and the sweet, lilting sounds of the Czech language to prepare her for the reunion with my father, or maybe with Alfred, the great love of her life. She stopped breathing five minutes after the closing credits.

After her death, I started to sort through all the documents and photographs she had brought with her to Santa Barbara. I was regretful that she had never told me about them or suggested going through them with me. But her vision was so poor by then, I think she didn't want to face not being able to really see them, to correctly identify and describe them, as I don't—or barely-read Czech. I was astonished at their breadth and scope—from both her family and my father's. She had carefully clipped explanatory notes to some of them, in English, but most were incomprehensible to me. The paper clips had rusted and stained them. After she died, I took many weeks to scan them into my computer, and began to experiment with enlarging them, noticing undiscovered details,

and then I began to use them in my artwork.

In fall 2006, I offered the Jewish Museum in Prague my parents' documents and photos and traveled to Prague to deliver them. I thought it was time for them to go home. I brought along a few of my original monotypes, and the museum personnel offered to exhibit them in Prague. My friend Simona, the daughter of Karel Stern (my father's friend from the camps), went with me to Terezín to meet separately with Dr. Jan Munk, the museum director, and they also offered me an exhibit. Both were to occur in September 2007, so I had a year to create and ship the work.

Creating images around the historical themes of my mother's life was a way to honor her and her experience as a Holocaust survivor, and to work with my demons as her daughter. Many of my early pieces reflect my need to make a mark on behalf of my parents, to tell their individual stories. While it was my mother's presence in my house that stimulated me to begin with, the content of my earliest work was mostly inspired by materials left by my father, who by that time had been dead for over a decade.

My half-sister Ritta had been one of the children in Friedl Dicker-Brandeis's art classes in the Terezín ghetto. Mme. Brandeis was a well-known Bauhaus artist and teacher who had brought art supplies to the ghetto, foregoing most of the "essential" personal possessions that deportees were allowed to bring. She had determined that she would teach art to the children in the camp. Heroic is too small a word to describe her. All but a few of her students, including my sister, perished. I believe Mme. Brandeis was on the same transport to Auschwitz with Ritta, leaving Terezín on October 6, 1944. Ritta's death announcement says she arrived there on the 9th. The artwork the children had produced in the ghetto was saved by another interned artist, Willi Groag, and has been the subject of books, films and many international exhibitions.

Here, it looks like Friedl was teaching botanicals to the children. In Ritta's drawing below, her name is barely visible above the date, in the top right corner.

May 24, 1944, Zimmerova, Marketa
Image #129351
Courtesy Jewish Museum, Prague

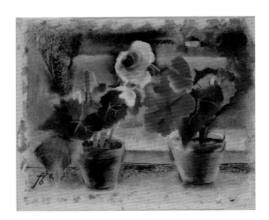

Friedl Dicker-Brandeis, Begonia at the
Window, c. 1934-1936, tempera on paper
Courtesy Jewish Museum in Prague

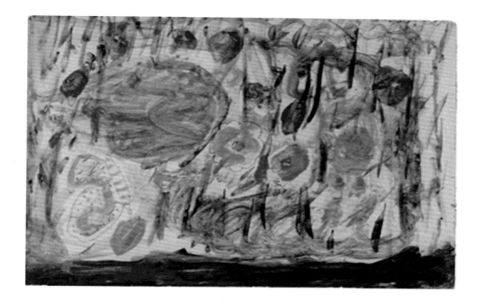

Zimmerova, Marketa
Image #125517
Courtesy Jewish Museum, Prague

This watercolor by Ritta appears in a well-known book of children's drawings and poems from the ghetto called *I Never Saw Another Butterfly*. I had been disappointed not to find any of her work in the first edition, but this image appeared in a second edition I found on my visit to Prague in 2006. I had seen this drawing for the first time in the Jewish Museum in Prague on a visit in 1979, almost thirty years before, and I had taken a picture of it, surreptitiously, to bring to my parents. It was the first time that we three together acknowledged that Ritta had existed. My parents framed the photo and put it on their dining room wall. However, I learned later that the original drawing had, in the late 1950s, been part of a traveling exhibit of children's drawings from Terezín that had been shown in Montreal. My parents had gone to see the exhibit, but my mother steered my father away from Ritta's drawing when she spotted it.

This was not the last time she tried to put herself between him and his memories.

I must have known this story of the Montreal exhibit, because I was consciously looking for the drawing on that visit to Prague in 1979. When I found it, I was dismayed because it looked like they had misspelled her name: Zimerova instead of Zimmerova. I was obsessed with a need for accuracy, even then. Only by naming things—and her—accurately could I be sure that Ritta was properly remembered. I was resentful of the fact that the Communists had been derelict in failing to properly preserve the memory of what had happened to the Czech Jews. The names of all the 77,000 murdered Jews had been painted on the wall of the old Pinkas synagogue in the 1960s, but it had been damaged by flooding, so it was closed for years. Despite several of her own visits to Prague, after 1968, my mother had never been able to enter or see her family's names. I felt I had to make up for this as well.

On my first visit after the Velvet Revolution, in 1992, I went to the museum office in Jachymova Street to ask them to correct the label on Ritta's flower picture, but was informed that the spelling they had used, with its diacritic mark over the "m," was an acceptable alternative in Czech to the double "m." I had been distraught for fifteen years over nothing. My visit had its own reward, however: the museum staff told me about other drawings by Ritta, and they gladly sent me copies. Even more recently, on yet another visit in 2014, they provided still more copies of drawings—having discovered that each piece of paper in Terezín was used twice and had drawings on the back as well as the front. So, going back over the same material over and over sometimes yields new insights, or at least, new material.

As Ritta's sole heir, I could have rightfully asked for the return of the originals of her drawings, but I only asked for copies. Then, for my

Smiling, Terezín Memorial Museum
September 2007

exhibits in the Czech Republic in 2007, I created the monotypes that incorporated fragments of the drawings, family documents, and my parents' stories.

Looking at this photo of myself smiling in the ghetto, now, brings up my dismay at seeing tourists taking selfies and sunbathing on the stone blocks at the Holocaust memorial in Berlin. But I felt somewhat triumphant that day in Terezín, and very alive. I had finally completed the task of preservation of memory, I thought. It was not the last time I have been wrong about that. But that day was not only about the past. It helped that I had come to the ghetto with a small busload of friends from California and my cousin, Peter, my mother's only surviving close relative. I experienced it that one time as an artist, not as a rootless, lost émigré, carrying

the weight of my parents' memories. But it still feels unseemly, and somewhat eerie—what the Germans would call *unheimlich*—to appear so cheerful in a concentration camp.

Terezín, called Theresienstadt by the Germans, was different from the other concentration camps. It had been a garrison town, constructed by the Emperor Franz Joseph II in the eighteenth century. It was inhabited by Czech civilians before it was converted into a ghetto to hold the Jews in late 1941. It was also unique in that the Nazis cynically encouraged much of the cultural activity that took place there for their own propaganda purposes. They dressed it up as a theater set for a visit by the apparently blind and witless Red Cross in 1944, and made a propaganda film about it, depicting it as Hitler's gift to the Jews—*Der Führer schenkt den Juden eine Stadt*—where it was described as a "spa" town. The Red Cross was willfully naïve in accepting the fraud. My mother described the preparations:

"Our last German commandant was Mr. Rahm and under his term the German authorities outside of the ghetto wanted to emphasize to the world and the Red Cross how well the Jews in Theresienstadt lived. They came up with the famous 'beautification program.' The whole ghetto was undergoing beautification; houses on certain streets were freshly painted and soon it was clear that they would bring the invited guests only on a route mapped out by them. Flowers and grass were planted in the main square, a wooden music pavilion built there, a merry-go-round for children and they opened a coffeehouse with musical entertainment. A funny incident happened a few days before the 'group' arrived. They had a rehearsal for the musicians and some 'customers' so everybody should know how to behave. The musicians struck up a popular song: 'Wenn das end will sein...' translated, 'When their end will come,' which was forbidden right away, and everybody had a private laugh.

"For days we had to wash the sidewalks, rehearse who

would be allowed to appear where and when, and the children
were instructed how to act and speak. Only healthy-looking
prisoners were to be seen.

"To make sure of this, in May 1944 the Germans hast-
ily put together two or three transports, comprising between
three and four thousand elderly people, the sick and those
from the tuberculosis hospitals ... for us a horrible price."

My mother's "job" in the ghetto administration was to find hous-
ing for newer arrivals and some of the elderly German Jews who arrived
were slow to accept their new reality. She wrote:

"One day a smaller group of elderly German Jews from
a new transport was assigned to our house. All of them were
very well dressed and had no luggage. At that time the house
was full as far as bunks in rooms went. To my surprise, they
asked me to assign them to a room with a view as that was
what they had paid for at the railroad station in Germany,
and to send them their luggage. It was extremely difficult
not to laugh in their faces but instead I tried to explain
that this was one of the jokes of the Gestapo in their home-
town and I didn't have any room with or without a view, not
even a bed or a mattress and, for the time being, I would
have to bring them to the empty attic where they were sit-
ting on the wooden beams; sometime later the same day their
luggage was found and we brought it upstairs with my helper.
I must have appeared as sunshine to them with their valises
and anything I suggested afterwards was okay, specially
when, on their first night, one of them tripped, broke her
arm, and I took her to a doctor right away.

"A few nights later, the same woman and her husband
committed suicide with some pills, which they had in their
damned valises.

"A German Jew was a special specimen. They still
were first Germans and, secondly, Jews, even after all their
experiences."

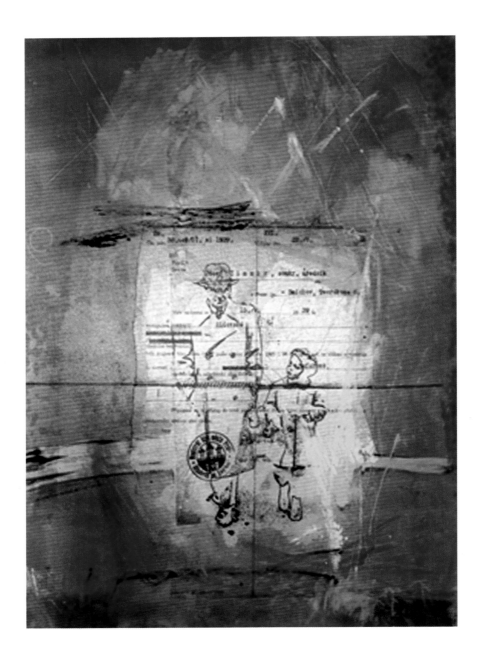

Vystup (2007)
Monotype with chine collé, 11 x 14 inches

6. Terezín Series 1995-2007

I have always considered "Vystup" to be technically the most successful of my images in the Terezín series. The collage element, which was printed on silk tissue, is almost seamlessly incorporated into the fiery background. This monotype with chine collé includes an altered version of the photograph of my father and Ritta walking in Prague together in 1937, and a family document showing my father's decision to leave the Jewish religion in 1939. The date on the document was so close to March 15, when Hitler came into Prague, that I wondered if my father was trying even then to save his family from what was coming. He later claimed that this decision "to cease being a Jew" was a result of a conflict over allegedly past due taxes to the Jewish community in Prague, which he had refused to pay. He told me he had been "excommunicated," and that after the war he had to "convert" to Judaism and had to go to the mikveh—the ritual bath—before the Prague rabbi would agree to marry him to my mother in 1946. I had not known that a Jew could be excommunicated until I read about the Dutch philosopher Spinoza, but there is also a centuries' old tradition of grooms going to the mikveh before their weddings, so he may have been mistaken. And he couldn't resist a good story.

My father always claimed that things could be true, without being completely accurate. I've been told that "exit" is not the correct translation of the word, "vystup." The fact that my parents did not want me to learn Czech as a child has created an additional barrier for me now. A separation from my origins. It is a very difficult language to learn, especially late in life, but I continue to be drawn to it and to cling to the remnants I do understand. I need to hear it to feed my soul as I need my bread dumplings and my schnitzel to give weight to my bell, to anchor me, somewhere.

I named the Prague exhibit "O Umění Zůstat stat" a title inspired by an essay by the Czech journalist Milena Jesenska, Kafka's onetime lover and a member of the Czech resistance, who died in Ravensbrück

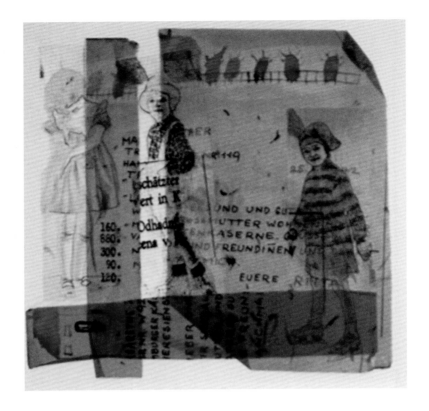

Grüsse Meine Freundinen (2007)
Monotype with chine collé, 11 x 11 inches

in 1944. I translated that phrase as "On the Art of Remaining Upright" for a Santa Barbara preview exhibit. It was pointed out to me that the phrase zustat stat can also imply "standing still" or it can even have the negative connotation of a paralysis, an inability to move in the face of crisis, cowardice even. Jesenská's essay from 1939 had the same title, so I kept it, hoping it would eventually be correctly understood as I had intended it, to honor resisters.

This collage on silk tissue included fragments of a postcard written on behalf of my sister by my father, set on a background of one of Ritta's drawings (Terezín drawing #130797). The girls are Ritta in the

Ballet (2020)
Digital collage

middle, in an incongruous costume as a Czech hunter, and Rita and Lydia Brand, the skater and the ballet dancer, my mother's much-loved cousins, murdered at Maly Trostinec, in Belarus, in July 1942.

The image of Rita Brand in her ballet costume keeps resurfacing in my work, most recently, for an on-line collage exhibit in Pardubice, Bohemia, the region of my paternal grandmother Berta's birthplace. This time I placed her in a barren landscape, being confronted by a monster. My mother was very close to Rita Brand and her sister, Lydia. She did not learn until the 1970's where they had died.

After returning from the Czech Republic I continued to make mono-types, and in May of 2009 I was invited to present my work in a solo exhibition in connection with the Choral Society's performance of Verdi's "Requiem," at the Granada Theater in Santa Barbara. The Requiem was performed in conjunction with a commemorative concert held that year in Terezín and dedicated to the inmates who had performed this music in inhuman conditions under the leadership of the courageous Austrian conductor, Rafael Shächter.

Much has been written about the art and music created and performed in the Terezín Ghetto, which was unique among the Nazi concentration camps in the extent of the organized cultural life pursued by the prisoners and tolerated, for their own reasons, by the Nazis. Aside from the "Requiem," along with Krasa's children's opera "Brundibar" and the folk play "Esther," survivors have said that the most memorable and stirring cultural event was the premiere of the iconic Czech national opera, Smetana's "Bartered Bride."

While the rich cultural experience pursued in Terezín undoubt-edly represented an aspect of spiritual resistance, attitudes toward participation in cultural life were a source of debate among even the composers working there. Viktor Ullmann wrote: "By no means did we sit weeping by the rivers of Babylon; our endeavors in the arts were commensurate with our will to live." Others worried about the negative implications of taking part in cultural activities initiated by the Nazis as part of their cynical scheme to deceive the world as to their genocidal intention. "The intended deception of [outside] visitors became the self-deception of the prisoners," said Livia Rothkirchen in her history, *The Jews of Bohemia and Moravia.*

My mother, who spent more than two years in Terezín, was one

of the singers in an inmate production of the second act of "Aida." She described how this engagement with music helped her to forget her dreadful circumstances, if only for a brief time:

> "There were two or three conductors I knew, and I was invited to participate with Mr. Fisher's group. He was a big Zionist, so that was our mutual background. We rehearsed for a month a few evenings a week the second act of 'Aida,' had a few marvellous soloists, a tenor from Holland, [a] soprano from the opera house in Vienna and another one from Prague. It was not only the pleasure of the few performances coming to the different barracks, for me it was mostly such an uplift to come to the rehearsals and forget everything for a few hours. There were a few very good comedy writers who performed witty sketches, which were the talk of the ghetto."

Because of these profound family connections to the history of the ghetto, and the role of artists and musicians in asserting human values in the depths of an inhuman space, I was honored to be asked to participate in this exhibit. In so doing, I was mindful of avoiding the notion that art on this subject can or should ever claim to be transformative of the experience of victims or survivors, so I continued to insist on the specific in my subject matter. In works like '*A na troskách ghetta budeme se smát* (On the Ruins of the Ghetto We Will Laugh),' I incorporated in the title the words of a song composed by Karel Švenk in Terezín, to honor the strength of the artist's and the survivor's spirit.

The chine collé element in this monotype is from a 1948 passport photo of my mother, taken when my parents fled the Communists to go to Canada. The handwriting in the background is from my grandmother Elsa's recipe book. Elsa was forcibly separated from my mother at Auschwitz and gassed in early October 1944. She was only fifty-seven years old but had serious vision problems and could not work. My mother

On the Ruins of the Ghetto We Will Laugh (2008)
Monotype with chine collé, 16 x 20 inches

was always terrified of her own loss of vision, perhaps because of Elsa's end, perhaps because her own glasses had been broken at Auschwitz, and she spent the last months of the war pretending she could see, so she could work in the slave labor factory, and not be sent back to be gassed.

By the time I was invited to participate in the "Requiem" exhibit, my mother had been dead for several years and I had started to direct my attention away from my father and Ritta to images related to my mother's experience, using altered photographs of her and my grandmother Elsa in

collages and monotypes, as well as excerpts from the manuscript of her life story, which she had begun writing in 1984.

Ironically, the opening reception for the "Requiem" exhibit in Santa Barbara was derailed by a large wildfire, which forced us to evacuate our homes. The fear of wildfire and of losing my family and all my possessions has been a primary source of my obsessive anxieties over the past twenty years. After we found safety, we actually spent a calm and happy week, waiting together out at the El Capitan Canyon campground on the Gaviota coast. My grandchildren made Andy Goldsworthy-inspired sculptures out of twigs. Once we were all safe there together, I was no longer afraid of the fire or the material losses. I follow my mother's model to always stay close to my family, believing we are safer together.

So intent was my mother on staying close to her loved ones that in Terezín, when my grandmother Elsa and Uncle Emil Brand, Aunt Nettie, Rita and Lydia were put on a transport list, my mother tried to join them, oblivious of the danger of the unknown, next place. She went to the person in charge of the lists:

"I told him my family was in the transport. He asked who and how many. I said mother and uncle with family, five altogether. He said, 'I can't take out all five, I will take out your mother.' I was stunned and told him, 'I didn't know that you could take out anybody, I came to ask you to help me and Alfred to be in the same transports.' His answer was, 'You are crazy and have a lot to learn about Terezin. Never volunteer, go back, your mother will not go.' Sad and much wiser, we discussed this with uncle (Emil Brand). They left and we stayed. I will never forget that fourteenth of July, 1942, when I walked with them, again bundled up in winter coats, to the barracks where they concentrated the group. I didn't let mother come with me to say goodbye and was glad that I spared her that.

"I never saw or heard of them again."

Thus, my mother lost all but one member of her immediate family. My mother's only brother, Fritz, was living in Bratislava, Slovakia, at the time but was arrested in 1944 and died in Sachsenhausen in the spring 1945, leaving behind a wife pregnant with my only cousin, Peter.

Because Peter had lost his father, before we left for Canada in 1948, my mother deeded my quarter share of the family house in Kroměříž to him. This house had been left in the hands of the Communists. Peter and his mother went to Israel in 1949, but he came to California in 1964 to study, and stayed. He eventually recovered his share of the house after the downfall of the Communists and sold it.

Peter and I agreed that in lieu of dividing the proceeds from the sale, he would have a Stolperstein (stumbling stone) placed in Kroměříž, in front of the building on Vodní Street, so there is something left to commemorate the Brand family. Apart from photographs and a 1930 painting of the Kavarna Brandova, the Stolperstein is the only physical trace remaining of any of our Kroměříž family that I know of.

I had started trying to get a Stolperstein placed in Kroměříž after I first saw one in Berlin on our trip in 2007. The one for Uncle Emil was finally installed in 2014. Gunter Demnig, the German artist who created the Stolperstein project, purposefully located the stones at the last freely chosen place that the Jew had lived, not a ghetto or a death camp. There are now over 70,000 such memorial stones all over Europe.

Just as I would like to see a Stolperstein for every single individual lost, in my artwork I keep insisting on specifics: names, places, dates, numbers. Lawrence Langer, the Holocaust scholar, taught about "literalists" and "exemplarists" in relation to the Holocaust. Exemplarists cannot tolerate looking at the Holocaust unless it can either serve as an "example," or as a redemptive instrument that informs our awareness. But, Langer argued, if the Jewish experience in the Holocaust can be made to stand for some larger human experience, then the danger is that

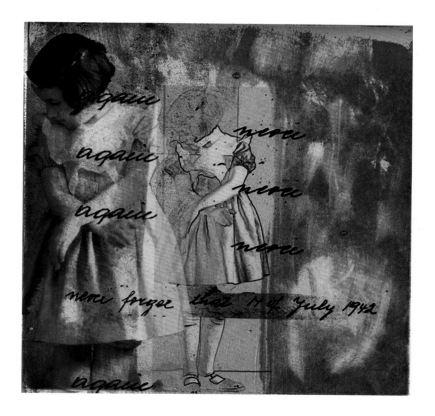

Never Again (2006)
Monotype with chine collé, 8 x 8 inches

the intolerable becomes more tolerable. A literalist, as I understand the term, insists on pointing at a specific thing and saying, "Look at this, it is no more or less than this." Since I identify as a "literalist," and I am insistent on the specific and the particular, I have questioned the purpose of turning to visual art at all, instead of continuing to study and document and organize information about history. For me, it was this: Listening to what happened is a moral obligation and it's one that I believe that I, as a daughter of survivors, have fulfilled. But remembering, in the right way, has been described as a spiritual act. And that is not complete, and probably never will be. After all, we do not say Kaddish for only one year.

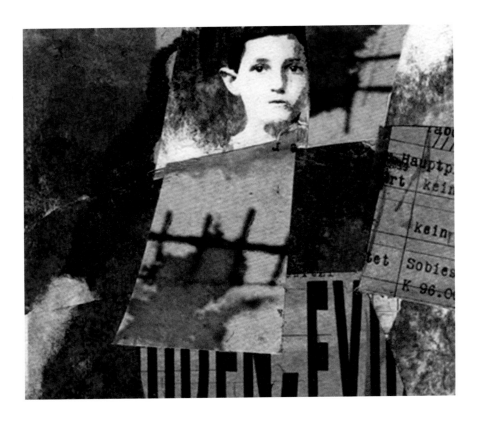

In Pieces (2011)
Collage on wood, 8 x 8 inches

My parents are both gone, as are the vast majority of the survivors. My father was the only one of his family who returned. It was forty years before he wrote about his experience. Beyond the recitation in his narrative of the details of keeping his "people" (as he referred to them) alive, virtually the only statements of his emotional life are simple declarative statements, like this:

"There were no happy days in the ghetto, or even happy moments. There were only quiet moments between transports."

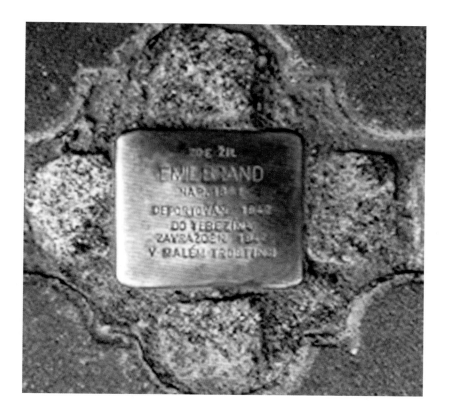

Stolperstein
"Here lived Emil Brand, born 1881, deported 1942
to Terezín, murdered 1942, Maly Trostinec."

Every word evokes the words not said, the words I will never hear. So I repeated these phrases in contexts of color, in juxtaposition with fragments of Ritta's drawings, with photographs of the life they had before, altered to look like the remnants of a life that they are.

Scholars ask whether after all the survivors have disappeared, the Shoah may leave traces of a deep memory beyond individual recall. While I do not believe that the work of remembering can ever be completed, I have an instinct that some elements of the spiritual and emotional

memory of the six million can be found in the arrangement of the components of a piece of art and in the spaces between.

Despite the near certainty that Ritta was murdered along with her mother immediately on arrival at Auschwitz, to this day I think she might appear—a sweet old lady like my mother had become, with a lilting Czech accent. The irony of periodically searching for Ritta is not lost on me; the fact is, if she had survived and been reunited with my father, I never would have been born, at least not as Jana Zimmerova, the Replacement Child. And I would have lost my raison d'être.

I kept a record from 2006–7 of my investigations and work in making the monotypes for Prague and Terezín. Being specific and intentional about my method seemed to be another way to be faithful to fact and detail, so I would not get it wrong. I began the work soon after my trip to Prague in September 2006, where I delivered my family documents to the Jewish Museum and showed Mr. Pařik and Mr. Munk at Terezín my artwork.

There was almost exactly a year between the time I began this process and the time tentatively set for the exhibitions. This seemed an appropriate amount of time for me to prepare. When my mother died, I had determined to say Kaddish for her every day for the entire first year. I did this in my half-ignorant way, at home rather than at the synagogue, and using a transliterated form of the prayer because the learning of Hebrew was not even a possibility in my father's house, and something I have failed to discipline myself to pursue. I felt that perhaps the process of creating this work was a delayed form of Kaddish for Ritta, too. And for my father, who would have at least scoffed, or perhaps even forbidden the saying of it.

I kept a diary to record my effort, making notes as I created monotypes. I began by trying to use imagery of the child's view of the Terezín landscape, and the relationship between my father and Ritta. The colors I used were the colors of the ghetto as I remembered them from my own visits: ochre, sanguine, black and burnt siena.

I was afraid I was dabbling in areas where I did not belong, and where I did not have the skills—emotional, psychological, artistic or technical—to do what I was doing. It was as though I was engaged in an alchemical experiment and I might blow myself up, or that I was dabbling in kabbalistic thought without the foundation of prayer, maturity and knowledge that is required. But I was compelled to proceed.

After a few months of struggle, I got an inkling that I might be able to find a way to honor and mark individual and collective history without denying, pre-empting, trivializing or otherwise staining memory and without necessarily continuing to suffer as though it had been my personal trauma. It was imprinted in my cellular memory, yes, but now I understand better that that does not mean I must continue to experience it as my emotional reality. When I said to a friend that I thought it was my task in this lifetime to internalize and memorialize what happened to my family, I received the stunningly simple response that doing this memory work does not mean I must continue to be tortured by it. And that I can receive life's gifts joyously. I believe that I have already begun to do that, and especially since the birth of my grandchildren, who are the best evidence of some kind of triumph over the evil that almost destroyed the entire lineage.

In the piece, "Postcard from Paradise," I used text from my father's handwritten manuscript and from a November 25, 1942, postcard from Terezín to a Mr. Levy in Prague. I failed to notice at the time I first saw

Ghetto Colors (2007)
Monotype with chine collé, 11 x 14 inches

it that the postcard had been written on my birthdate, four years prior to my birth.

I am fascinated with these lines of text because my father's hand-writing is so uniform and perfect that it appears almost like a carpet woven in a factory, consistent with the meticulous way he approached every task in his life. Never a deviation from the regular formation of letters. I recognize that the postcard, too, although purportedly from Ritta, was in his hand, but he printed it in block letters, not in cursive. I assumed this because each person in a family was allotted a certain number of cards or letters that were allowed to be sent to persons outside of the ghetto. Initially, I believed that he used the block letters so it would pass muster with the censors, as having come from a child, but I later learned that the messages on the postcards had to be written in block letters in German and couldn't exceed thirty words. I don't know to whom my father would have written, since the whole immediate family was there with him, and I don't know who this Franz Levi was, presumably a relative of Kitty's or maybe not a relative at all, but someone else on the outside to whom my father was attempting to send a message.

The words on the card broke my heart.

Dear Uncle,

We are all healthy and in good spirits. Mother and grand-mother live with my father in the Sudeten barracks. Say hello to my friends and think of me sometimes.

Your Ritta

Postcard from Paradise/Alle Gesund (2007)
Monotype with chine collé, 11 x 14 inches

I spent many weeks digging deeper into Ritta's artwork, magni-fying her images, which seemed at first to be the meaningless scribbles of a child. As I enlarged the images, I found a universe of creatures and objects that seemed both contemporary and totemic. Peeling an onion, going into this interior world and an interior life that I, as a then sixty-year-old woman, projected onto a child of ten, who was probably shielded as much as possible from understanding her ultimate fate. This felt a little like going into a body, into the organ, into the cell. But what was I digging for? To try to establish a dialogue or a relationship with a child I never knew, that I would not have known how to talk with had I

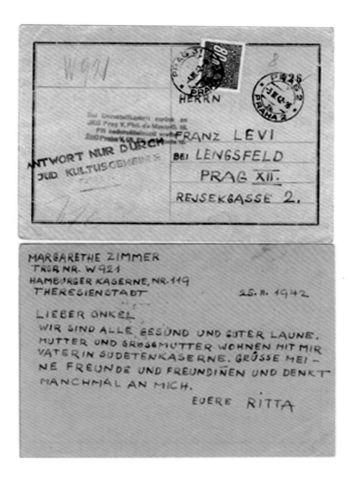

Postcard from Ritta to Franz Levi
November 25, 1942

known her? In some way, yet again, to rewrite history and bring her back to life? I didn't know.

One Sunday, during this process, my grandson, Max, dragged a box out of the hall closet that I had forgotten about, which contained additional family photo albums. There were many pictures of Ritta as

Altschul Family
Cleveland, Ohio, 1937

an infant and small child, some with her mother and my father. And an additional "family" photo which I do not recall ever having noticed before, of a very large, very well satisfied and obviously well-off family at an elegant celebration in Cleveland, Ohio, in November 1937.

Based on the notation on the back of the photo, the celebration appeared to be a milestone birthday or anniversary of one Ernst Altschul. This was the branch of my grandmother Berta Altschul's family, which had gone to America in the early 1900s. I remembered my father's description

of his visit to Cleveland in 1946 and how poorly he had been treated by them. How he must have felt, looking for some remnant of family after the war, and them not even asking how their European siblings had died.

My father wrote:

"In Cleveland lived at that time one of my mother's sisters. I don't know anymore if I had her address or if I found her name and address in the telephone book and I phoned her. She lived with her daughter, my cousin Florence (nee Altschul/Wolff), and we agreed that Florence's husband will pick me up at my hotel and bring me to their home. He did and it was a little bit of a formal reception. They didn't behave like people who see a nephew and cousin, the only living person of the family... But I didn't want anything from them and I didn't get anything, not even dinner despite that it was dinner time. The aunt didn't ask how her sister died, the cousin didn't ask how her cousins died. They didn't ask how long I will stay in Cleveland and didn't invite me for a second time. I have not seen them or heard from them since."

I made a monotype with chine collé in which I altered this photo of the Altschuls and included a fragment of my father's handwritten account of his visit, but I discarded it. I am reminded yet again that looking at artwork that tries to directly convey the experience of these people is too hard for me to bear. And I have no right to portray it. My purpose, as it evolved in my own mind, was not at all to describe, as I could never be competent to do that, or to externalize an experience that I never myself had. Rather, I aimed to evoke what and who was lost, to reinvigorate, to restore to these people their own voices and if not that, some accurate aspect of their being, so that they count as more than a date and a transport number. To see them as ballet dancers and skaters and hunters

Cancelled (2007)
Monotype collage on silk tissue,
11 x 11 inches

and laughing children. So that hearts would break and open. I put Hanna and Pavel Zimmer, my Uncle Otto's children, and Rita and Lydia Brand as well as Ritta into the same monotoype and called it "Cancelled."

My father described Otto and his family affectionately, and even though Otto's daughter, Hanna, was only a year apart in age from Ritta, my father never described them all being together:

"Always full of life, easygoing, tall, healthy, and independent. He graduated from textile school, became a textile draftsman, and later with a large textile corporation, as a technician. He liked movies, theatre, and music, had a very good singing voice, and was an excellent dancer. He was also a talented amateur actor. He liked girls and was an acknowledged expert in this field. He loved life. After my father's death he quit his job in Prague and took over the business in Soběslav. He married in 1926 a very pretty, good natured Karla Reich, who was a very good wife and businesswoman. They had a son, Pavel, born in 1928, and Hanna, born 1931. They led a good quiet life until the Nazis came. They lost the store, Otto worked as a laborer on a farm, they were deported in 1943 and murdered in Auschwitz."

When my cousin, Peter, and his wife, Hagar, joined us for the openings of the exhibits in Terezín and Prague, Peter suggested that we meet in Berlin beforehand, and that we stop in Dresden and Freiberg on the way back to see if we could find the slave labor factory where my mother had been a prisoner from October 1944 to April 1945. At the time, I did not realize that this side trip would plant the seeds for the completion of the other half of the family story: what my mother experienced after her time in Terezín and Auschwitz, Freiberg and Mauthausen, and the artwork I that I created for a second exhibit, in Freiberg, in 2015.

September 1, 2007, was a propitious day for the trip from Prague to Berlin —the anniversary of the date of Hitler's invasion of Poland and the official start of World War II. Another stab of painful recollection, when the train passed the sign for Bohušovice, which was the end of the rail line from which the Czech Jews then had to walk the remaining three kilometers to the ghetto, carrying their allowed possessions.

My mother wrote:

"As far as the things we could take with us, it was not more than 50kg per person, except for what you carried on your person. Therefore, even though it was June when we left, we all put on our heaviest winter clothing and shoes. Many, many thoughts and lots of work went into the prepa-ration. To avoid extra weight, we didn't take suitcases, made rolls which served as bedding and blankets, summer and winter clothing, medication, some pots and pans, a little folding chair (not knowing how far we'd have to walk), for Alfred the smallest basic medical instruments, and some food. We knew by heart the weight of every handkerchief and so we packed and unpacked hundreds of times. Around the neck was our transport number, mine was AAG 252."

For every pleasant experience on our train from Prague to Berlin, my mind conjured up its dark counterpart. Our "relatively" good goulash and *houskové knedlíky* (bread dumplings) in the separately appointed dining car of the Prague-Berlin express contrasted with images flashing through my mind of my mother's train trips through Europe, especially the transport from Freiberg through Plana and the Czech lands to Mauthausen, to the horrors of the quarry and the final fear-filled days. She had no dining car. To the contrary, the only food they received in the two or three days the transport stopped in Plana was the warm soup organized by the wife of the mayor there, a Czech.

In Berlin, we only saw the outside of the Holocaust Memorial and instead searched out the 1943 Women's Protest memorial in

Rosenstrasse because it represented a unique example of German resistance to the Nazis. I was not as interested in the historic sites in Germany as I was in artistic responses to the Holocaust, of which there were many. In the Daniel Liebeskind-designed Jewish Museum there were many young Germans stationed throughout as "helpers," all dressed in black with red scarves bearing a strange zig-zag symbol that reminded me of either a deconstructed swastika or a deconstructed Star of David. At the recommendation of one of them, we went to the special exhibition of the gouaches of Charlotte Salomon, a German Jewish artist who perished in the Holocaust and whose work had drawn me in for many years, especially her use of color and text.

Displayed in an adjacent building to the museum, there were almost 200 of her 769 drawings from her *Leben? oder Theater?* (Life or Theater?) dramatized autobiography that she created in 1940–42 while in hiding with her grandparents in the south of France. I knew that all the women in her family, including her mother, aunt and a grandmother, had over the years committed suicide, but I had not known that her father, her lover/teacher and her stepmother survived. And it has only recently come to light that she also deliberately poisoned her grandfather, who—she wrote—sexually abused her. Charlotte, newly married and five months pregnant, was arrested and later gassed at Auschwitz. She was twenty-six years old.

The most compelling image for me was a line drawing, almost devoid of color, showing the young woman sitting alone on a bed in front of an empty suitcase—packing for emigration/deportation—and Pope Pius XI saying, "Tiens, tiens, tiens (hey, hey, hey) what are all these little Jews doing here?" It said everything about the complicity of the Catholic Church. What was amazing was that it was so clear to Charlotte that she depicted it in her work, contemporaneously to the events. Everyone knew.

Adjunct to the Salomon drawings was a video installation by the French filmmaker Chantal Akerman. Again, I was drawn to the use of text, both typeface and handwriting projected onto a screen, as Akerman interviewed her own mother. I was surprised at how light in tone the conversation appeared to be. Akerman's mother had spoken of a friend who was very strong in the camps, but then collapsed after the war and never left her house. The strong and beautiful girls who she expected to survive were dead within days. I was shocked to learn later that Akerman herself committed suicide at the age of sixty-five. When I left the exhibition and was confronted by a guestbook to sign, I reverted to my old trick of avoiding the emotional intensity of my reaction by writing, in French: *"Pour ma mère qui ne s'est pas suicidée."* For my mother who did not kill herself.

Later we walked through the Brandenburg Gate looking for the Sunken Library, an installation by Micha Ullman, an Israeli sculptor, commemorating the book burning in the square directly in front of the university in 1933. If I had not been looking for this memory piece, we wouldn't have found it. There was nothing above ground at all, just a transparent one-square-meter "window" set into the stones in the middle of the square. When we looked down into it, we saw a room with walls of empty bookshelves. On the surface, about twenty feet away on either side there are plaques set in the ground with a quote from Heinrich (Harry) Heine, in 1820: *Wo Man Bücher verbrennt, verbrennt Man am Ende auch Menschen.* "Where books are burned, in the end, people are burned."

I started to feel queasy and angry. That was the emotional disconnect with strolling through the Auguststrasse and the surrounding streets, filled with galleries, cafés and hip design and fashion boutiques. Every single building had been purged of its former Jewish inhabitants. *Judenrein*—literally, "purified of Jews." And you have to be looking very hard and very intentionally if you want to see the evidence of what was

here before. This signifies to me that the only people who will be educated about the past are those who already know it. I wondered then if my feelings of grief and sadness would spill more easily on the surface in the Czech lands, especially in Terezín because of my own connection, or whether I would be so burnt out from looking at Shoah-related things that I would be numb.

There were small brass plaques in Oranienberg, a former Jewish neighborhood, placed either on the buildings, as in the case of M. Kaufman the kosher butcher who was required to leave—*müsste gehen* —in 1939, (would have to go), or on the ground in four-inch squares, as in the case of a Mrs. Shirmer, who was deported from that particular house in 1942 and killed at Riga in 1943. Who sees this? Who notices? Jews like me who come to Berlin looking for it might, but even I did not notice the street plaques until Hagar mentioned them.

This had been the beginning of the Stolpersteine, or Tripping Stone project, I later learned. There were so many of the memorial stones in Berlin, and not just in the Auguststrasse area, that some of them appeared worn. It was shocking to learn the origin of this idea—that in German tradition, if one tripped over a cobblestone, the saying went that "there must be a Jew buried nearby." So now the tripping-stone triggered the memory of the Berlin Jews whose place of death is usually known but who have no graves because they went up in smoke, or—as ash— were tossed into fields or rivers. There were no markers other than these tripping stones at their last known address. This artist was even more mordant than I had realized, the conception much more complete, this conscious inversion of a traditional German expression, turned on itself.

"Berlin is not Germany, now we are in Germany," commented Peter's wife, Hagar, after lunch in Dresden. She was so right. From the moment we got off the train in a huge Bahnhof with no escalators,

and walked into town for lunch, it was an entirely different emotional landscape. The people looked far less prosperous and much more East German, pre-*Glasnost*. Downtrodden. It had been less than twenty years since the fall of the Berlin Wall. And the youthful, friendly and open faces of Berlin were virtually absent. Instead, Dresden was blanketed in a small-town eastern European air of resentment. The waitress at the crowded, Ratskellar-style basement restaurant was downright hostile, refusing to replace the small bowl of soup she served to Peter with the larger one he had ordered.

I hated it there. I felt angry and helpless to change my circumstances, and I didn't know what had possessed me to think making this side pilgrimage was either necessary to honor my mother or to do anything other than inflict pain and misery on myself. I started to believe that the factory where she had been enslaved in Freiberg would have been torn down; that we wouldn't find it and would wander around pointlessly. Finding it was Peter's idea, and it had seemed worthwhile, to stop halfway between Berlin and Prague, to visit the place my mother had been a prisoner.

I wrote in my journal:

"I'm trying to figure out the best way to go do this task in Freiberg. Apparently, it will be by train or taxi. I just feel I want to get it over with and get back to Prague. They are actually playing military music all over the place here in Dresden, in the street and restaurants, *oomp pa pa oomp pa pa*. They are all about rebuilding this fantasy medieval village. All over the place it is about Dresden as it was, and implicitly before 'they' did this to us—the firebombing in February 1945. As if the townspeople had not been complicit.

"Saturday morning, September 8, if the sky could look more grievous, I don't know how. Utterly gray, the ground is wet. A continuation in the pervasive mood of gloom and doom. At least it looks like the

wind has died down. Last night ended with some reassuring news, one of the desk clerks researched the location of the former porcelain factory where the airplane works were, and—it is now a part of the city administration of Freiberg. So we have a specific address and the whole excursion now is focused instead of being an exercise in aimless and despairing wandering. I went to sleep a little calmer.

"I was touched by the care with which the young hotel clerk took on the task of researching. He not only volunteered to research and copy the information from the German website I had found about the factory, but when it was delivered to our room, I noticed that he had translated it with Babelfish. A very strange, and almost incomprehensible translation—I kept wondering why it mentioned Free Mountain (which is German for Freiberg), and then it recites that the 1,000 Jewish women who were sent from Auschwitz for labor there were liberated by the Americans at a place called House of Duty (Mauthausen). This was almost comically inappropriate."

What did bring more tears of rage was to understand for the first time that the selection by Josef Mengele at Auschwitz II-Birkenau had not been just a pronouncement that these "happy few" were fit for work. No, there was an affirmative policy of *Vernichtung Dürch Arbeit*. Vernichtung—destruction—to be made into nothing—through work. Not just enough to let them die, but an affirmative choice to kill them by working them to death.

When I understood this well-thought-out purpose, I got a sudden insight into my mother's later description of the frenzied activity at the granite quarry at Mauthausen, her last camp. Having survived two years in Terezín, the selection for labor at Auschwitz, and the six months in the freezing factory in Freiberg, she was still made to "work." There was still no "Warum." In the universe of evil that the Nazis built, it made

sense to force prisoners to run up and down the stairs carrying stones as heavy as they were, even at the end of the war, when there was no point to it at all. My mother described the last days at Mauthausen:

> "We were put in barracks similar to Auschwitz, crowded and called for roll call and put to work cleaning the 'streets,' some of us carrying stones to and from the famous Mauthausen stone quarry with, I forget now how many, about ninety ugly steps down."

At this point, after three years of a starvation diet, my mother weighed about 70 pounds. They were still trying to kill her, although the war was lost, and they had disconnected the gas a few days before her arrival at the end of April 1945.

So, in that moment, in Dresden, I thought of bringing the photos I had with me of my grandchildren, Max and Sophia, and inserting them in a crack in the factory wall, like a prayer, instead of flowers or a stone, as would be appropriate for a cemetery. It was as if to say, "Here it is, you bastards, the evidence that 'Vernichtung' did not completely obliterate us. The fourth generation of one Jewish family is here, in your face." Again, my feeling, in keeping with the atmospheric sadness, heaviness and depression, was one of bitterness.

On that Saturday, after some confusion about the process of ticketing and direction, we managed a train from Dresden to Freiberg. A taxi took us to the building at 43 Frauensteinerstrasse, "Womens' Stone" Street. A fitting name, given my mother's testimony regarding the noise their wooden clogs made on the cobblestone streets of Freiberg, as they were marched from the barracks to the factory at 5 a.m.:

> "The people living along the street we walked to and from work were not too happy, even sending complaints to the factory about the noise at five in the morning. Imagine, 500 people in wooden shoes marching on the street. It was

'blackout time' constantly, they were not allowed to switch the lights on and then at six o'clock the other group coming back from the nightshift and noise again. And the morning hours were the only time they dared to go to bed, the RAF by that time back on their way to England. We didn't care, we didn't sleep either."

We found the ruins of the factory building and two memorial plaques on the wall under a portico, protected from the weather. I left the photos of Max and Sophia with the family tree and a note, as well as two long-stemmed, white roses I had bought at the railroad station. I chose white because when I saw them I thought of "*Die Weisse Rose*," the White Rose resistance group, and Hans and Sophie Scholl, the young university students who paid with their lives—guillotined for leafletting against the Nazis. I thought I might be arrested for littering, for leaving the note and the flowers on the ground and wondered what reaction the person might have who first saw my little offering that Monday morning. I was glad no one had seen us.

Afterward, I broke down, but both Peter and I were glad that we had come, and that it was done well and properly. I felt that the family mission had been accomplished. We rewarded ourselves at a café in town with poppy seed cake and tea and a taxi back to the station. Freiberg was eerily quiet, we thought, for a Saturday morning, but were later reminded that we were in the former East Germany, and that people were not in the habit of spending unnecessary time in public places, tending to stay with family at home. We returned to Dresden in time for lunch and then escaped on Saturday afternoon on the train to Prague. I was anxious to get out of Germany, having done my duty.

The formal opening celebration for my exhibit in Prague was perfect. First there was music by pianist Jiři Hosek and his daughter

Nachworts/Afterword
Photograph courtesy of the author

Dominica Hoskova on cello. I was told he is one of the best pianists in Prague and they played a beautiful piece written in Terezín that had only recently been discovered in Israel. Later I learned that their mother and grandmother is Helga Weissova Hoskova, a well-known Terezín artist with whom I had chatted before the recital. Anna Lorançova, who was also a child survivor, got up to speak of her appreciation for my efforts and we discovered that she probably had lived in the same Hamburg barracks as Ritta. And we chatted with the woman who sang the role of the cat no less than fifty-five times in the ghetto performance of *Brundibar*.

Despite the painful history, it was a joy to share this experience not only with Simona, who had known my parents, but also with Peter, Hagar, and the friends who came to join us from California, most of whom also had known my mother. We celebrated with dinner at the Café Jacques in Prague, and they propped me up the next day for the vernissage in Terezín.

We had chartered a bus for the sixteen of us and arrived at Terezín in time for lunch at a restaurant in the ghetto, whose name I have forgotten. I think it was called "Memorial." The contradictions, not to mention the commercialization of memory, were disorienting. We rushed through the heavy meal. We hadn't been told a specific time to arrive at the museum, and when we did, the staff were somewhat frantic as we were almost late. We had not been familiar with the custom of formal presentation at art openings, and their punctuality in beginning their programs. At the entrance the staff thrust a bouquet of roses at me, and we went in to hear the speeches and the music.

I was overwhelmed by seeing my artwork displayed in the same room as "real" Terezín artists and felt some shame over my vicarious efforts, my insecurity rampant. My art was beautifully presented and displayed, and they had organized a reception with food and wine. I was anxious to get out of there, but we stopped at the Magdeburg barracks, which had housed the offices of the different departments of the ghetto's so-called Jewish Self-Administration, where my mother had worked. Magdeburg now hosts exhibitions with artifacts from the living areas, authentic but sanitized, and on art and music in the ghetto. When I learned that a few of my monotypes were still displayed there years after my exhibition, I was surprised and grateful that they hadn't been consigned to the archives in the cellar.

However, on that first day and after over a year of preparation and anticipation, I was strangely devoid of emotion. I did recall a feeling of

having successfully completed an obligation in a way my parents would have been proud of. That was enough.

The next day we traveled in Simona's car from Prague to Cesky Krumlov. In addition to Přehorov and Soběslav, both places from my family history, we found the village of Tučapy, where my paternal great-grandmother, Francesca Roubiček, was born in 1829. The municipal office was open but empty, and on a large regional map we found a Jewish cemetery and synagogue. There was virtually no one around to ask except two silver-haired men drinking beer at 11:30 a.m. in front of a grocery store. I greeted them in my best Czech and asked whether they knew where the Jewish cemetery was (*Kde je prosím židovský hřbitov?*).

The younger of the two men claimed to know and offered to lead us there on his bicycle. We followed in the car and came to a forest where the cemetery lay behind an ancient wall. The gate was locked, and we could see nothing but the top of a headstone. The man said he thought he knew who had the key, so he hopped on his bike again and led us to back to a house in the village, where we were greeted by two large dogs. The housewife came out and, after telling us her husband had the key and should be working at the cemetery, she returned with us and walked along the wall until she found her husband. We were in.

When we explained that I was looking for the grave of my great-grandmother, he said there were lots of Roubičeks and walked us through the cemetery he had been restoring for a decade, although it was unclear who employed him. He apologized for mistakes in his restoration work because, at first, he didn't know that the gravestones had to face east, toward Jerusalem, in anticipation of the resurrection. And as neither of us read Hebrew, we were not successful in finding Great Grandma Roubiček's grave. Back at his house he showed us some historical documents, about a dozen pages, typewritten at least sixty years

before, which he said had been compiled by a Jewish teacher of his who was a history buff. There were lists of family names and house numbers in columns, one in roman numerals, the next showing the Arabic counterpart. I saw one reference in his documents to a decree in 1594 from Count Rozemberk declaring that Jews could not live in Soběslav. This is why there are so many small Jewish communities, because the Jews were allowed to work in the towns but could not live (or die) there. I didn't find the name Roubiček on his list.

The whole encounter was a revelation to me, especially these three strangers who were willing to help me find what I was searching for, just because I needed it and they were able to. In the cemetery, because I knew in my heart that my ancestors were there, I left a stone on the oldest grave I could find. Until that day I could not connect myself to any relative further back than my peddler great-grandfather, Jacob (Vitek) Zimmer in Soběslav. I learned that the name Roubiček—which I had not understood to be particularly "Jewish"—derives from Reuben, which in turn is a form of the biblical male name Reuven, the first-born son of Jacob and Leah and the ancestor of the Jewish tribe named after him.

Traveling around, we headed to Frymburk, a small and lovely resort town on Lake Lipno. We were on the edge of the Sumava forest, and the scenery was classically Czech—rolling hills peppered with forests, mushroom hunters trudging down well-worn paths, picking fungi that would kill the unwary in an instant. Even though I had never lived in that landscape, it was strange how comforting and familiar it felt. My mother had taught me her recipe for mushroom soup. I wondered aloud why the Czechs never offered their Nazi occupiers a nice, "traditional" Czech mushroom soup and laughed to remember my father's favorite word for nonsense —*Houby!* Mushrooms.

After lunch at the Vltava hotel, we strolled along the lake shore,

Jewish Cemetery, Tučapy, Bohemia, 2007
Photograph courtesy of the author

where I was struck by the peacefulness of the environment and the near silence of the lake. Not even the small ferry to Austria seemed to carry any real noise. The soothing and calming effect provided a smooth landing for me emotionally from the pace, pressures and intensity of the previous few days.

In Krumlov, I found an old map of Berlin in an antique store. I had been thinking there would be something to say, in imagery, about the feelings that had come up about our trip to Berlin and Freiberg, so I was happy to have found this visual tool to use. I determined to broaden and change my approach to make it less a personal narrative and I've always loved to work with maps.

The next morning was full of surprises, all pleasant. We went to the castle in Krumlov with the intention of booking only the *Divadlo,*

"Sudeten Claims," Cesky Krumlov, 2007
Photograph courtesy of the author

the baroque theatre tour, and found we had an hour on our hands, so we strolled through the castle complex. There was a warren of subterranean, dungeon-like rooms, one leading to the other, and always down, down.

Eventually we fell upon an exhibit depicting the clamoring of the descendants of the Sudeten Germans who had been expelled back to Germany after the war and were now seeking redress for their displacement.

I hadn't ever wondered about their fate, considering them only as a pretext for the Nazi occupation of western Czechoslovakia, and therefore complicit.

My husband and I left southern Bohemia behind and drove to Kroměříž, Moravia, where we had lunch on the grand square, opposite

the corner where my grandfather Sigmund Brand had built the family café—Kavarna Brandova. After a walk, I went into the Kroměříž Muzeum, which had some books about Jews in Moravia and Kroměříž under the Nazis, and I bought them even though they were in Czech. From what I could understand, one book seemed to assert that all the named members of my family had fates unknown, birthdates unknown. This was not the case, and I set an intention to provide the museum with the correct information.

We walked toward the former site of the synagogue that the Nazis had burned down and found a small sculpture by the Czech artist Olbam Zoubek there. I felt so angry about the desecration of the cemetery on site. Somehow, the fact that the Germans took the time and trouble to destroy existing graves, exhume the bodies and dispose of them, flattened me. Their aim to not only destroy the Jews physically, but to extinguish all their culture and the memory of them, seemed without parallel in history, at least at that time to me. Being in Kroměříž, which is such a lovely, sedate town, imagining the life my family lived "before," was, to my surprise, the most difficult part of the trip for me, missing my mother, feeling lonely for family. I was surprised at the depth of the sadness and anger triggered by the visit. What does it mean to feel at home? I have a foot in both worlds. Exile? Am I still in exile? Not from a place but from a life that was lost and which I would or should have been part of, both as part of a chain of continuity and a circle of family.

I was also shocked to learn from the book I found about the Kroměříž Jews that my mother's first husband, Dr. Alfred Loeff, had lived until March 3, 1945. Yet my mother had believed that when he arrived in Auschwitz in the transport ahead of hers, in September 1944, he was immediately sent to the gas chambers with the children he had cared for. To learn that he was alive two months before liberation was another nail in the heart. Yet, had he survived, there would be no progeny with the

combined DNA of Josef Zimmer and Klara Kohn Loeff, so what should I have wished for? And the books have not been entirely correct in other respects, so I will never know the truth of it.

Azulejo
Photograph courtesy of the author

Diaspora (2007–2015)

The images in a collection called "Sepharad" were prepared for a private exhibit of my work, and a book called "Collaboration" that I made with Portland artist Sharon Marcus, after a trip to Portugal and North Africa in the fall of 2010. This project evolved from a desire to study and connect in my artwork to the Jewish Diaspora, and the themes of exile, memory and community, as specifically reflected in images from the Iberian Peninsula and North Africa.

My use of the Portuguese and North African images eventually focused on a few that are emblematic of three themes. Here, they emerged as a particular *azulejo*, a quintessentially Portuguese tile which in this seventeenth-century example depicts three Jews in a boat, holding a Torah scroll (and, I imagined, referencing the Hebrew traveler's prayer), a receipt card depicting the wartime work of the humanitarian Renée Reichmann, who sent chocolate to my mother and other aid packages to the imprisoned Jews from her safe haven in Tangier, and the words of Aristides Mendes de Sousa, known as "the Portuguese Schindler" [*Meo Objectivo Salvar Toda*—My Objective to Save Them All].

Mendes de Sousa was posted in Bordeaux, France, at the beginning of World War II. He defied the orders of the Portuguese dictator

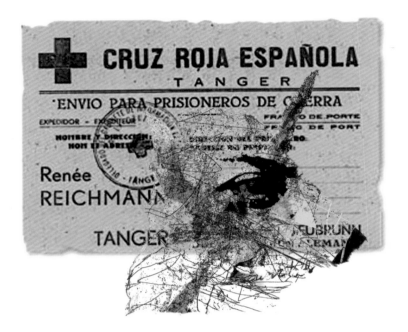

Meo Objectivo Salvar Toda /
My Objective to Save Them All (2010)
Digital Collage

Salazar and wrote thousands of visas for Jews fleeing Europe to enable them to cross Spain and enter Portugal. Even after the German army entered Bordeaux on June 27, 1940, the diplomat continued to issue as many as 30,000 Portuguese visas to Jews who were stranded there, knowing that such documents might prevent them from being deported to concentration camps. After he left Bordeaux and returned to Lisbon, he was dismissed from the diplomatic service and was denied retirement and severance benefits. Aristides Mendes de Sousa died in poverty in 1954.

We discovered the story of his work quite accidentally when we drove from Lisbon to the town of Tomar to visit the medieval synagogue

there. It is one of only two pre-expulsion synagogues remaining intact in Portugal. We wandered into a room adjacent to the main structure, where the mikvah—the ritual bath—had been located and uncovered, and found a small, very modest temporary exhibition dedicated to Mendes de Sousa's heroic work.

Even the history of this tiny synagogue speaks to multiple exiles and returns. The Jewish community in Tomar dates to the early fourteenth century. Built in the middle of the fifteenth century, it had been abandoned for centuries before a Polish-born Jew, Samuel Schwarz, restored it in 1921. An engineer who was working in Portugal's mining industry, Schwarz documented Jewish customs in rural Portuguese locales in a 1925 book entitled *New Christians in Portugal in the 20th Century*. These customs had been preserved in towns like Belmonte and Trancoso by descendants of Jews who kept practicing their faith in secrecy after the Inquisition, a state-sponsored campaign of persecution that began in Spain in 1492 and reached Portugal in 1536. In Belmonte, Schwarz wrote that only three Jewish holidays were observed: Passover, the Fast of Esther—part of the Purim holiday—and Yom Kippur. On Yom Kippur, Jews would meet to play cards so as not to appear to be worshipping, and, he claimed, they are still following the custom today.

My parents liked to play cards with their friends, but not for the same reason, and not on Yom Kippur. On that day, my mother fasted and my father, ever contemptuous of religious observance, took me out for lunch at the Ellwood Steakhouse on Decarie Boulevard in Montreal. Since all my parents' friends were Eastern European Ashkenazi Jews, I had virtually no understanding or knowledge of the history of Sephardic Jews. I had been vaguely aware that one boy in my high school class in Montreal was a French-speaking Jew from Morocco, but, regrettably, I had no curiosity about how he his family might have ended up there.

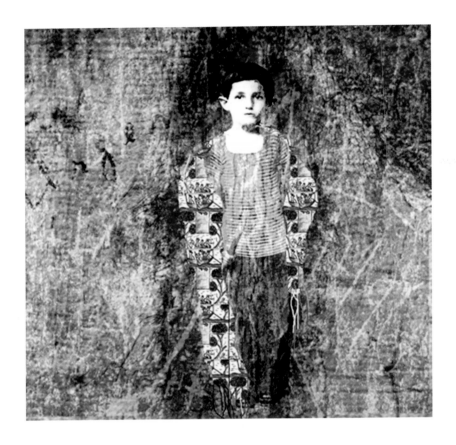

Boy (2011)
Digital collage on wood, 8 x 8 inches

7. Diaspora

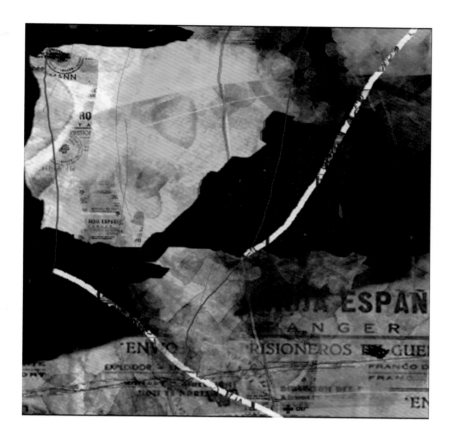

Iberian Map with Ribbons of Routes (2011)
Digital collage

Images in my art that began as snapshots in time and were intended to document individual losses seem to have yielded over the course of the months I worked on the collaborative project with Sharon Marcus to ribbons of a constant flow of peoples, the lost and the saved, speaking to multiple exiles and returns. I imagined these ribbons swirling back and forth and around the Mediterranean, like seaweed that appears to be detached, floating randomly on a watery surface, but which is anchored to the sea bottom.

But my questions still remained. Is there but one root, spiritual and physical, and is it Zion? Or is Diaspora necessarily the same as Galut/Exile? Is it possible to be fully a Jew where one happens to live, as my father, the anti-Zionist, always claimed we must do—even after Auschwitz? Or is it possible to feel at home in a tiny Mediterranean country, eating hummus instead of schnitzel, without knowing the language, and feeling completely alienated and ashamed by the seventeenth-century religious mentality that is so privileged there?

When I had returned to America from Prague and Terezín in 2007, having completed my mission—I thought—and having delivered the aesthetic as well as the historical documentation of my family's travails to the root source, I was quite paralyzed in finding a new or next direction for content in my art. I realized that I was completely absent from the work I had taken to Europe.

I spent a number of weeks pursuing and using imagery from Berlin to try to say something about the experience of visiting Germany for the first time, but with very limited success.

I felt only absence and emptiness. So, I decided to focus on improving my technical skills—composition, color mixing, printing. I started to see that more abstract imagery might help me to clear the

Lost Letter (2008)
Monotype with chine collé, 8 x 8 inches

plate, so to speak, to allow emotion to speak for itself; to try to bring to the surface and work with the notion of foreboding that permeated my consciousness. I could see that I had consistently shifted the focus of my anxiety from the external—death/destruction by firestorm—to other members of my family, and that overwhelming fear of loss. The constant sense of foreboding needed to be examined and brought forward.

After Klee (2008)
Monotype, 8 x 8 inches

My abstract painting teacher saw the work I had done and suggested that I look at the work of Arthur Dove, Albert Pinkham Ryder, and Ad Reinhardt—three early American abstract painters. Instantly I attached myself to the melancholy and foreboding in some of their forms. I tried some more of these types of prints—abstract landscapes to express the desolation, my sense that something was waiting just at the edge of the image to overwhelm and destroy it.

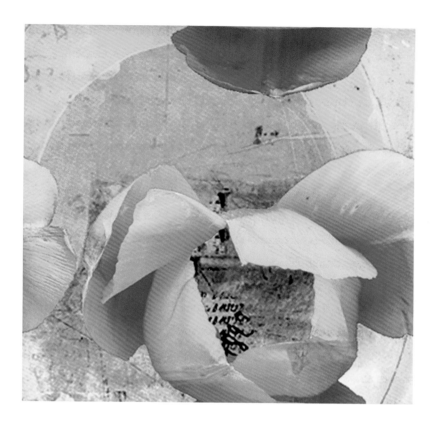

Tulip Petals — Fritz (2012)
Monotype with chine collé, 11 x 11 inches

That phase did not last long.

This digital collage includes dying tulips that I photographed in the Keukenhof Garden in Amsterdam. After we visited the Anne Frank House and Dutch Resistance Museum, I incorporated the tulip, as well as the names of the Dutch Jewish children who died in the Holocaust, in numerous pieces. Wherever I have traveled, especially in Europe, I

continued to feel compelled to look for connections to Jewish history. The themes of exile and loss recurred everywhere I traveled—images reminding me of the war, deportations, the few brave rescuers. In Denmark we visited the small fishing village from which Danish rescuers transported Jews to Sweden. In Sweden I photographed a monument to Raoul Wallenberg, and altered it in numerous images.

Eventually, all this seemingly aimless exploration brought me back to my mother and her story. Without any deepening of my understanding, I began to see my own life in relation to this subject as a mathematical Moebius strip, an endless loop of repetition, with the occasional flash of connection.

Just as I had never expected to find a connection to my mother's experience in Terezín in a book about Spanish Jews during the Inquisition, I was not looking for a family connection on a visit to Catalonia in 2014. It was to be entirely a pleasure trip focused on Gaudi, Dali, Picasso, and other Spanish art and architecture. But history followed us to Barcelona, and beyond. We took a city walking tour with a British guide, visiting the sites representing the history of the Spanish Civil war and learned about the half a million refugees from Franco's army, who fled to France. This became known as "La Retirada" (the Retreat). Since the start of the Spanish Civil War in July 1936, Franco's forces had brutally repressed Republican sympathizers whenever they seized new territory. They executed unionists, teachers, intellectuals, artists, even workers. When Catalonia fell, there were a lot of people already there who had fled from other regions. They were afraid that the repression would be even worse this time around. They chose to leave for France, which was the only escape route possible. These people were initially held in internment camps in France on the beaches in Argelès-sur-Mer and Saint-Cyprien.

7. Diaspora

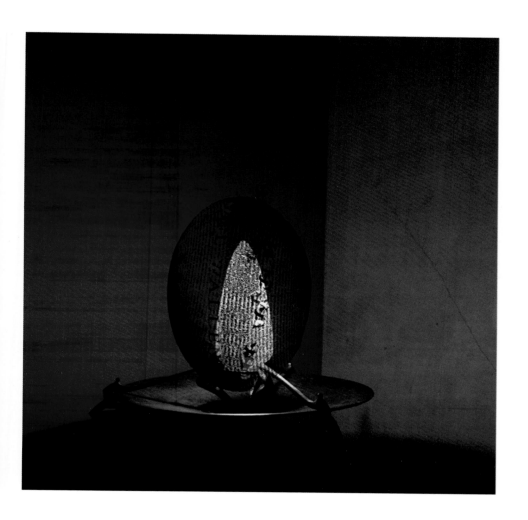

For Wallenberg (2013)
Digital collage

The story of them pouring over the border resonated with me, but it was a while before I understood that there was a connection to my mother.

She had written in her life story about an infection she got in her ankle from marching back and forth from the barracks to the slave-labor factory in Freiberg in ill-fitting wooden clogs. After the evacuation of the Freiberg camp and their arrival at Mauthausen concentration camp in Austria, she was finally seen by someone with medical training. She wrote:

> "A Czech prisoner, 'an old timer,' also referred me to a surgeon, a Spanish Communist, who looked at the messy hole above my ankle and decided to fix it. He didn't speak German and, of course, not a word of Czech and I jokingly said to the Czech orderly-prisoner that I knew how to count to ten in Spanish as I had taken some lessons in preparation for immigration in 1939, so he would know when I was asleep. The orderly told me not to worry about that, they didn't have any anaesthetic to spare for this, that the doctor was very fast and good, and after the first cut I might faint for a minute or two but, in the meantime, my leg would be fixed. It must have happened that way..."

I had wondered, when I first read my mother's manuscript, what a Spanish Communist would have been doing in Mauthausen. I found out when we went to the Museum of the Exiles on the French/Spanish border in La Jonquera, Spain. I discovered that thousands of the Spanish leftists who had fled across the border in 1939, and who were first incarcerated in camps in southwest France, were deported to Mauthausen. Some of them survived six years there, hence the presence of a Spanish surgeon, available to treat my mother's foot in May 1945.

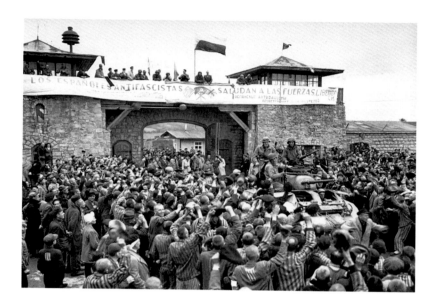

May 6, 1945 — Mauthausen survivors cheer the soldiers of the Eleventh Armored Division of the U.S. Third Army one day after liberation.

Photo: Donald R. Ornitz. Public domain, via USHMM, courtesy of the National Archives

In this photo, the banner above the gate to Mauthausen reads: "The Spanish anti-fascists welcome the liberating forces." They freed the camp on May 5, 1945. Only in recent years—since the death of Franco—have their memories begun to be honored.

On that same trip to Spain in 2014, we drove through Portbou, the coastal border town where the German philosopher Walter Benjamin had entered from France in 1940. He was a refugee in the other direction, fleeing France to Spain, seeking transit to Portugal, where a visa to the United States awaited him. In ill health, he had trekked across the Pyrenées carrying a briefcase of his most precious manuscripts, with Lisa Fittko, a woman who guided scores of refugees to safety in Spain. On arrival in Portbou, he was picked up by the Spanish police, who

Walter Benjamin's hotel bill
October 1, 1940

were going to send him back across the border, to be deported back to Germany. It was extremely bad luck. Due to changes in Spanish border 'policy', had he arrived the day before or the day after, he would have been allowed safe passage. He killed himself that night.

I looked for references to this event and found the hotel bill.

It appears from the itemization that it was much more expensive to dress the corpse and disinfect the room than to provide the great philosopher with food and lodging in transit. And it would have cost

them nothing at all to let him pass through Spain to freedom. I don't remember reading who paid the bill. When Benjamin's friend, Hannah Arendt, passed through Portbou several months later, there was no trace of his grave.

Bertold Brecht, who was a friend of Benjamin, wrote a poem called "On the Suicide of the Refugee W.B."

> *I'm told you raised your hand against yourself*
> *Anticipating the butcher*
> *After eight years in exile, observing the rise of the enemy*
> *Then at last, brought up against an impassable barrier*
> *You passed, they say, a passable one.*
>
> *Empires collapse. Gang leaders*
> *Are strutting about like statesmen. The People*
> *Can no longer be seen under all these armaments*
>
> *So the future lies in darkness and the forces of right*
> *Are weak. All this was plain to you*
> *When you destroyed a torturable body.*

There is more than one story about how and where Benjamin is buried. One had him interred in the Catholic cemetery under the name Benjamin Walter. On the hill overlooking the sea at Portbou, we found a memorial, conceived by Israeli artist Dani Karavan. Titled "Passages," the memorial is a sculptural installation that is integrated into the landscape. Visitors enter a passage that slopes down through the cliff face before it falls vertically into the sea below. Progress is blocked at the point that the passage falls away by a glass screen on which this quotation from Walter Benjamin is etched in five languages:

"It is more arduous to honor the memory of the nameless than that of the renowned. Historical construction is devoted to the memory of the nameless."

Knowing my mother's story, knowing her, comparing her account to this, I was momentarily taken aback that Benjamin unhesitatingly chose suicide rather than face the possibility of deportation to a concentration camp. My mother endured the privations, the starvation, the beatings, the misery, always hoping for a change for the better, and did not consider suicide herself until afterward, when she realized that she was the only survivor in her immediate family.

I had not known that she weighed her choices coldly after returning from Mauthausen to learn that everyone she had loved was dead: whether to commit suicide or have a child. She chose the latter. She never told me this, and did not write about it, but confided it to my daughter-in-law when I was not present. She told Andréa that women just did not choose to have babies out of wedlock at that time, so she settled on identifying a husband. In the immediate post-war period, after the initial activity of reclaiming her home and her belongings—when she still believed that her husband and brother might return—she wrote only that she was depressed and restless:

"When I finished furnishing the house and Alfred's office, I sat down at his desk and, maybe for the first time, admitted to myself that nobody who had lived there with me and belonged there, would come back.

"Thinking back, I realize that this time was the worst of the thirty-five-month experience. There was always some hope for change, but to admit to yourself what the heart refused to believe — that you are all alone in the whole world...

"I locked the house and left for Prague to stay with Marta and Hedy, who were both in the same boat. After a few days, I came back again, not being able to stay in one place. It happens that Marta's birthday is a few days ahead of mine, and we decided some time earlier that we would

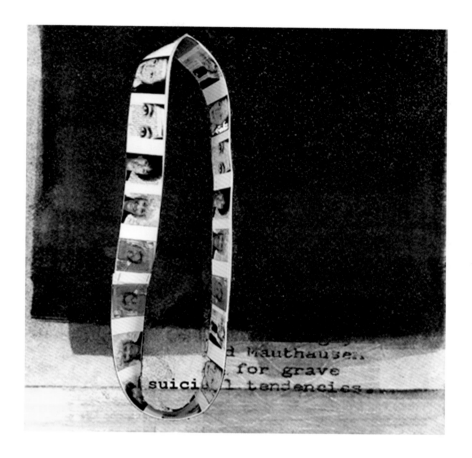

Suicidal Tendencies (2019)
Digital collage on monotype,
with medical report

spend it together, fearing the loneliness. I left a day
ahead and arrived sort of unexpectedly. Marta had a date
with Karl Stern to go to a movie. I offered to stay at home,
but Karl called up a friend who didn't have anything better
to do that evening, so he came, and later became my husband
and your father. The next day we went out together and then
he invited us all to his place for some coffee. His house-
keeper baked a good cake and didn't like me from first sight.

"I traveled almost every month to Prague, stayed with Marta, and became very close with Daddy. Soon we decided that we wanted to get married and start a new family. Because we both lost our former partners in Auschwitz and didn't have any official death certificates, we had to apply to the court for a death certificate, setting the day of probable death with a remark that your marriage was annulled.

"This way they allowed you officially to pick up the pieces and start a new life.

"Daddy made all the arrangements, we had a civil wedding ceremony at the old city hall in Prague, Marta and Karl were our witnesses, and I moved into Daddy's place. The next day the housekeeper left."

I contrast her narrative, rich in emotional detail, with my father's description of their first meeting, succinct and without sentimentality, in the same paragraph where he recites that he acquired an apartment when he returned to Prague in May 1945:

"After some arguments and fights I got an apartment in a modern building with central heating in a good district. Karl Stern's girlfriend was expecting a visit from a young lady with whom she was in Mauthausen concentration camp. She tried to get somebody to be the fourth in the party. Karl asked me and October 27, 1945, I met Klara Loeff and I am meeting her every day since. We got married August 2, 1946."

They met on her thirty-third birthday, and they were together until his death in 1984.

Klara's beautifully tailored suit, sewn, I suspect, by her friend from Mauthausen, the prominent Prague dressmaker, Irma Brod, disguised the fact that she was by then more than five months pregnant.

Soon after my mother died, I made a semi-abstract collage, using the colors of the rose and salvia bushes that we planted for her on the patio outside her room, her cardiogram, and fragments of a report that

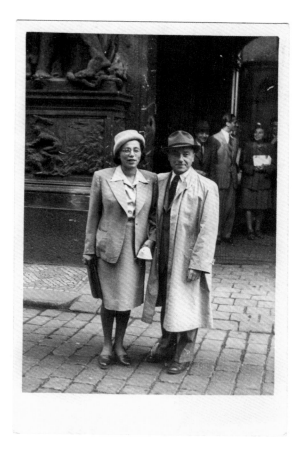

Wedding
Prague City Hall, 1946

she sought in order to qualify for reparations payments from Germany. She mentioned that she had been angry at the psychiatrist, who at first couldn't perceive any disability.

As a result of my encounter with Walter Benjamin's story, and his quote about the names and the nameless, I wanted even more to rescue my parents' and my family's history, and their names. Taking my art back to Prague had not been enough. I had to do more for my mother.

Bread and Salt (2018)
Collage from life drawing, on wood, with a fragment
from Grandmother Elsa's recipe book, 8 x 8 inches

Siblings of the Heart

My mother was born in 1912 in Bucharest, where her father was working for a Czech company. On her seventieth birthday, which fell on October 27 on the Roman calendar, she began to write her life manuscript at my request. When she agreed to finally tell her life, it was 1982, and aging survivors were just beginning to speak about the Holocaust. I wanted to know her whole story and how I fit into it as her only child and as a member of what was then beginning to be called, by the therapeutic community, the "Second Generation."

When I was growing up, in the 1950s and '60s, my mother did not speak of her experiences, and in those days, she rarely showed her emotions in any case. When she was older, she described having locked her feelings into an imaginary "black box" that she had conjured around her heart as a small child, after her own father died in World War I when she was only four. I had never seen her cry, except once, when Tommy Vilím, her friend Liza's little boy, with whom she had a special connection, died of leukemia in Montreal in 1962. At times I fantasized that she had lost a child herself in the war, a child she hadn't told me about, and that Tommy had replaced him in her heart. But there was never any real evidence of that. In fact, my mother and Alfred had only just married and built their home when the Germans came.

The things my mother wrote or later told me about her experiences that brought her, and me, to tears were not her descriptions of horrifying loss, but those of moments of human connectedness—moments of decency that were shown to her—where despite the risks, a few ordinary people treated her with compassion, and times when women, especially, cared for each other.

She wrote, for example, that there were "orders" in the last months in the Terezín ghetto that any pregnancy among Jews was to be "interrupted." Failure to comply meant immediate transport to the East, and certain death. However, some women had become pregnant by their husbands just before their deportation from the Terezín ghetto to Auschwitz and did not realize it until well after their arrival in the slave labor camp at Freiberg. Despite the danger and the lack of food, they did not want to abort—their pregnancy was the last remnant of their former married life and represented their hope that they would survive to see their husbands again.

"I didn't mention that during the last month in Theresienstadt there was an order to interrupt pregnancies. It had to be taken seriously because the other alternative was a transport to the east. Nevertheless, when we arrived in Auschwitz, some health changes happened to all of us. We immediately lost our menstruation and changed back to normal only a few months after returning home. It was explained to me that the emotional shock and starving diet were the reasons.

"At any rate, it was a blessing. But, of course, the girls who were at the beginning of their pregnancies and didn't know, not able to check the basics in Auschwitz, found out much later. We were all terribly worried, fearing that our Commandant would get rid of them when our doctor made his report.

"He must have had a dual personality; he agreed to keep the girls, I think there were four or five at different stages,

who stayed as factory workers. He issued bigger rations and
lighter work in their latter stages. And so, my friend, Anka
Nathan, also brought her unborn baby to Mauthausen."

My mother wrote about the cattle car journey from Freiberg to
Mauthausen in April 1945. Even though the Germans were clearly losing
the war, they continued to maniacally move the remaining Jews around
Europe. Whether they were determined to complete the annihilation, or
to hide the evidence of the genocide, or both, is not clear:

"They loaded us onto a train, the first three days in
open wagons. April in Europe is a cold, snowy, sometimes
rainy time, hell on earth. We couldn't even sit down on
the floor all at the same time, there was a shortage of
wagons, so they crowded us in tight. The train went slowly
through Czechoslovakia, at least familiar surroundings.
Near Karlsbad, the train stopped on a side-track and we were
transferred to closed wagons to go someplace and waited
and waited.

"There were bombardments and military trains had
privileged departures. People in this small place called
Plana* were marvelous. They persuaded our commandant to
allow them to bring us warm soup. The whole village came
later with soup and bread and repeated it for the next two
days. The wife of the mayor or village doctor, I forget by
now who he was, found out that a girl from Slovakia was preg-
nant and would soon give birth and she brought and shared
with her stuff for the baby. It seemed like a miracle. We
thought this was home, these were our people, and we were
theirs."

(* Researchers maintain this occurred at Horni Briza,
a few kilometers away, but I retain my mother's recollection,
here. Her memories have proved accurate on other occasions
when they were challenged.)

Most fortunately, the gas for the gas chamber at Mauthausen had
run out the day before my mother's transport arrived there. Some days

after that, the Russians and then the Americans entered and liberated the camp, and after a few weeks, they organized a different kind of train to transport the remaining survivors home to Prague.

> `"The Czech boys dressed up the wagons with flowers and signs 'Z pekla Mauthausen — domi' translated meant 'from the hell of Mauthausen — back home,' and that was the truth. I left with the first group with all my close friends on the same train, even Anka Nathan with baby Eva, born in Mauthausen."`

I never gave this mention of Anka Nathan and her baby, Eva, much thought until decades later, in 2015, when I was preparing to go back to Freiberg myself for an exhibition of my artwork. The organizer of the exhibit, Michael Duesing, was a German high school teacher of my "vintage," as he said when he introduced himself, who had spent many years documenting the history of Freiberg and the 1,000 Jewish women who had been selected by Mengele in Auschwitz for slave labor.

Like so much of this story, my relationship with Michael kept turning around on itself. I don't remember for certain how I first came to know him. It must have been through the young webmaster of the Freiberg City website, who had sent me a picture of the factory when I was researching reparations lawsuits, just before my mother died. I had shared with Michael some of my mother's anecdotes about her time in Freiberg for his first book in 2002, *Wir Waren Zum Tode Bestimmt* (We Were Destined for Death). Michael and I communicated for the first few years by email, but we did not meet during my first visit to Freiberg in 2007, when I had left the white roses and my angry note at the memorial to the Jewish women laborers.

It had been a few years since our last correspondence when in 2011 I was surprised to receive a copy of Michael's second book in the

mail, with no letter. He had marked with a yellow sticky the page where he had reproduced and included the note I had left at the factory site in 2007, as the Epilogue. It said, *"We Are Still Here/Wir Sind Noch Da."* He described how a German municipal worker on the Monday morning after our visit had found the note and delivered it to him, knowing that he was writing the history of the town during the war. Learning that the note had been treated with respect unfroze my heart.

We restarted our correspondence and Michael eventually suggested that I exhibit my art in Freiberg, along with a Czech and a German artist in April 2015, on the seventieth anniversary of the liberation. In the meantime, Michael published his third book, *Zwangsarbeit fur den Endsieg* (Slave Labor for the Final Victory), which included photos and more facts about my mother's story that I had shared with him. I gave him an image of my mother's face, superimposed on a photograph of the factory, which he used on the book's cover. On the back cover he used a monotype depicting Ritta and my father in Terezín on a background of one of Ritta's drawings. Thus, Ritta's drawings kept following me, even into my exploration of my mother's story, which was entirely separate from my father's, as they had not met until after the war.

A few weeks before the trip to Freiberg for the 2015 exhibit, I was contacted by a British writer, Wendy Holden. Wendy was researching the story of three women survivors. All had been prisoners in Freiberg, had become pregnant before being separated from their husbands, and had given birth in the last days of the war in Europe—one on a plank in the factory at Freiberg, one on the transport between Freiberg and Mauthausen, and one at the gates of Mauthausen. Of the three, it is certain that my mother knew Anka Nathan, whom she mentioned twice by name in her manuscript and described as her friend. I believe she also must have known a second woman whose name was Priska Löwenbeinová.

Factory (2015)
Digital collage

I inferred this after I reviewed the galleys from Wendy's book. In it she reproduced the registry of prisoners at Freiberg, and my mother's name, Klara Löff, was just above Přiska's—Löff, Löwenbein—along with her birthdate and prisoner number, #54 193, which was one digit

away from Přiska's. I'm not sure whether this was a number assigned at Auschwitz, or on arrival at Freiberg, as none of these women, including my mother, were tattooed. While I doubt they were close friends—Přiska was Slovak, my mother Czech, and my mother did not mention her as one of her group of friends—I imagine they must have stood together at some point in alphabetical order. So Přiska may have been "the girl from Slovakia" who gave birth at Freiberg. But there had been several pregnant women.

I willingly shared parts of my mother's manuscript with Wendy, to assist in her research, and she in turn put me contact with Eva Nathan Clarke, Anka's daughter, in England and Hana Berger Moran, Přiska's daughter, in Northern California. I spoke with Eva on the telephone for some time, both of us quite emotional. We later missed meeting each other in Europe by a few weeks: in May of 2015 Hana and Eva went to Mauthausen with Wendy and another "miracle baby," Dr. Mark Olsky, for the book launch of *Born Survivors*. The release of the book was timed to coincide with the seventieth anniversary of the liberation. I had been in Freiberg for my exhibit opening a few weeks earlier but had decided not to extend my time in Europe to join them. I did not want to go to Mauthausen or Austria at all. My mother always said the Austrians were even more enthusiastic Nazis and a lot less remorseful than the Germans. I had visited Vienna the summer I was in school in Switzerland, age fifteen, and apart from the Sachertorte at the Café Mozart, where my mother had known the owner, it held no charm for me.

I have since met Hana, when she came with Wendy to Los Angeles in March 2017 to promote Wendy's book. Hana and Eva have graciously included me in their tiny club of "siblings of the heart." They were born days before liberation, and I was born about a year and a half after, in 1946, but we are certainly of the same historical and emotional era. I think we all believe to a degree that our mothers' experiences

were transmitted in utero and imprinted on our hearts and souls, even though our lives afterward took very different turns, mine in Canada and California, Eva's in England and Wales, and Hana's in Slovakia, Israel and then the United States.

In the time between my Prague and Freiberg exhibits, apart from looking for traces of Jews in the Diaspora, I continued to toggle back and forth between my father's and my mother's experiences in my artwork. My mother had always mediated the relationship between me and my father; in some ways she had invented it. In more recent years, I have paid more attention to my mother's history, and her voice comes up more often as I remember my past. This might have been because she was with me so much longer than he, or that it took me that long to throw off my father's domination of my psyche, so I could see her at all. Because the loss of a child seems always so much sadder and more poignant, even when my focus was intentionally on my mother's story, the extreme tragedy of my father's loss intruded, again and again.

My first intention in turning to focus on my mother's experience was to print collages on my napkins and her gloves, from better times, in prewar Europe. We had been using the napkins and my mother's china for Passover Seders with friends for decades. I realized eventually that the "K" monogrammed onto some of the napkins was in fact "KT," the initials of Katerina (Kitty) Thiebenova, my father's first wife, not KC, Klara Cohn. So, this was a set of napkins that I only thought I had inherited from my mother, and it turned out that the loss of Kitty and Ritta still overshadowed everything else or was at least still the "substrate" for my efforts to look at my mother's story.

The first napkin I printed included the image of my father and Ritta walking in Prague before the war.

One of the collage elements in the background included the year 1932, Ritta's birthdate.

8. Siblings of the Heart

Linen Napkin #1 (2015)
Digital collage on linen, 15 x 15 inches

Over the years, even as I have begun to let go of Ritta, my attachment to the "sisters" I have appropriated in my own life has been connected to the war, even when it does not seem to start that way. So, I hold tight in my heart my "Prague sister," Simona, daughter of my father's best friend from the war, Karel Stern, who with his brother George was with my father in Auschwitz and on the death march from there to Gleiwitz in January 1945. Simona knew and felt close to my parents, and once told me that she, too, had periodically looked for Ritta on my father's behalf, and once thought she had found her in Prague, teaching high school. She was about the right age, but that woman was not Ritta.

My "New York sister" is Marcela, Karel's younger daughter, who escaped the Communist system in 1985 and was with us in California for a short while before she settled in New York. I can't fathom the courage it took to leave behind her own mother and sister, and their home in Prague, for the unknown, perhaps forever. I fear that if I lose these sisters, I will lose my connection to the past and to my own beginnings in Prague. I have tried to stay connected to Simona's daughter, Zuzanka, but that generation, Zuzanka and my son Geoff, Zuzanka's children and my twin grandchildren will have to find each other on their own. They will have to do what they do to maintain these ties, or not. But it is not easy for me to watch the connection fade.

Apart from Eva and Hana, the most surprising sister relationship that I have gained in recent years is with my friend Dayna. When we met in 2011, I thought we could not possibly be more different, or have less in common. But we clicked immediately; we seemed to see things with the same eyes, and with the same dark and absurd sense of humor. After we had known each other a few months, we were taking a walk together and I mentioned that my mother been a survivor of the camps.

Dayna said that her mother, Helen Kalins, had served in the U.S. Army 130th Evac Hospital Unit, and had followed Patton's 3rd Army

around Europe at the end of the war, nursing survivors in the liberated camps. I asked her which camp, and she wasn't sure, but said she thought the name started with an "M."

At that time her mother was ninety-three years old, and living with Dayna and her husband, Steven, so we went up to her apartment right away to talk to her. Helen immediately confirmed that the camp was Mauthausen. Dayna and I both became tearful as she spoke. At that moment we decided that her mother had liberated my mother, we were connected for life, and that was that. Later, when Hana Berger and Wendy Holden came to L.A. to promote Wendy's book, we all agreed that Dayna should also be a sibling-of-the-heart, because Hana was herself nursed by the Americans who came into Mauthausen in her first days of life there. We decided that Helen probably helped to save her, too.

Dayna then sent me her own mother's memoir, describing her three months' work in Mauthausen, (which she called "Mooshaven"), and which, like Wendy's book, was much more brutal in its details than anything my mother had told me about conditions in the camps. I don't know whether forty years on, when I finally had asked her to write her story, my mother's memory had softened, or she wanted to spare me. I use photographs of her from before and after the war in my work frequently. The one from 1948, taken for her passport photo to leave Czechoslovakia and start again in Canada, seems ineffably sad.

My mother's experience of liberation, too, is described in relation to her friends, and how they cared for one another:

"I asked an American officer, in my broken English, who I knew worked in administration, if he could bring me a pass to leave the camp and I promised that I would come back. The next day I got one.

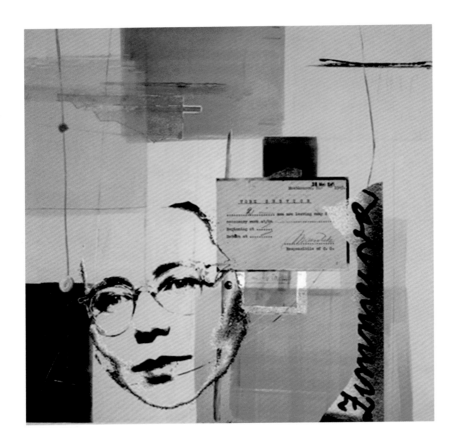

Work Service (2011)
Digital collage

8. Siblings of the Heart

"There was a girl with us, Eva Reich, who had eye-glasses which she occasionally lent me to look at the real world, and she remembered mine had been broken in Auschwitz.

"I told her that I could take her for a stroll down to the village with me if she would promise to lend me her glasses for a while. She felt miserable that day, both physically and mentally and didn't want to go. ... I persuaded her to let me borrow the eyeglasses and promised a sure, safe return. To my surprise, she didn't object and I left, a happy pair — me and Eva's eyeglasses.

"I walked down through the forest, meeting other prisoners, but in the middle of the way I saw a little brook and next to it blooming patches of blue and pink forget-me-nots. I sat down there for some time, picked the biggest bunch, and returned to camp. Eva cried with happiness, these were her favorite flowers, which her mother had always given her among other things for her birthday, which was supposedly around this time.

"The other girls called me crazy, telling me better to bring something to eat next time. Coming back at the gate, a prudent American soldier told me that I couldn't go to the village in the outfit I had on, meaning men's long underpants and a shirt. When I said that was all I had, he suggested I hang a blanket around me.

"I came out of there better because of Irma Brod, who was in our group and who was a dressmaker in Prague with a very good clientele. She took a nail and tore the blanket in the right places to make my first wraparound skirt (an outfit I came home in). Upon my request, she made another one for whoever would go with me next time. The next day Lola Viba volunteered. Dressed up with Eva's glasses on my nose again, we walked down through the forest and open fields to the village. The other girls were still too weak and didn't feel up to the long walk.

"Walking through the village, a little boy stopped us and asked if we would like some food. Of course, we did, and he jumped over a low fence, I assume not his parent's house, and brought a good-sized goose, twisted its neck and gave it

to me. We took it, our thinking didn't always work too well, but a few minutes later smart Lola said, 'What are we going to do with this? We don't have anything to clean it or cook it in.'

"We just happened to pass by a house in front of which an elderly woman was tending their vegetable garden. You could see in their eyes how afraid they were seeing us walking into their house. I told them to prepare the goose for tomorrow, we would pick it up, and they shouldn't dare to keep something for themselves. Lola's German was on the weak side, so it was up to me to do the talking. They told us how sorry they were about what was happening up the hill, citing the old German song, 'they didn't know about it,' which made me mad as hell.

"The next afternoon we picked it up. Lola, being more of a gourmet, thought that a fresh salad might be good with it. So, I asked for green salad from their yard, dressing in a bottle, the goose to be carved up in small portions, and we walked 'home' to camp for a special meal.

"I remember only that the goose was very tough and there were no leftovers."

This was the pass, dated May 18, 1945, that was issued to my mother by the American C.O., allowing her to leave the camp to walk free for a few hours.

From the liberation and afterward, her friends helped her to get through:

"... at the railroad station in Prague, I said good-bye to my friends: Martha, Eva, Irma, Hedy and Lola, all from Prague, promising to be in touch, not even realizing at that time how much we would be needing each other for moral support in the next weeks and months."

When Anka's daughter, Eva Nathan Clarke read the draft of this manuscript, she asked me about Eva Reich—one of the women who had

U.S. Army-issued pass for Work Service
Mauthausen May 1945

remained in touch with Anka after the war. She told me that Eva Reich's son had also published his own mother's life story, and in it she referenced the same five friends—Marta Waldstein, Irma Bord, Anka Nathan, Eva Reich, Hedy and Klara—my mother. I immediately ordered the book, and I was stunned to read that Eva Reich (Bunzel), whose glasses my mother borrowed at Mauthausen, had lived in La Jolla, about twenty-five minutes' drive from my mother's house in San Diego. And in the same community as Helen Kalins, Dayna's mother. Eva Reich had died in La Jolla in 1993, two years before my mother came to Santa Barbara to

live with me. Eva even mentioned her love of forget-me-nots in her own account.

Eva and my mother came so close to meeting again, but I'm quite sure they didn't. My mother would have mentioned it. But these add-on stories make me feel I can never really finish my own, because each new discovery shifts my perspective, and sends me on a new search. I don't know what else, or who else, might be out there. On the other hand, perhaps the only way that those that are meant to find me will do so is if I put this book out into the universe.

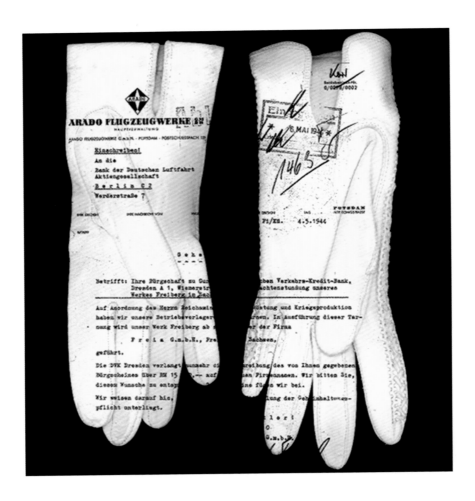

Gloves Arado (2015)
Digital collage on wood, 10 x 10 inches

Return to Freiberg (2015)

It was in 2014 that Michael Duesing first proposed that I participate in an exhibition marking the seventieth anniversary of the liberation of the camps with two other artists: Helga Weissova Hoskova, a Czech artist who'd also survived slave labor as a teenager at Freiberg and Mauthausen—and who I had met briefly in Prague when she attended my exhibit in 2007—and Stephanie Busch, a young German artist from Dresden. While the images in my previous exhibits were heavily weighted toward my father's experience through Ritta, I intended for this exhibit to be focused on my mother.

Nevertheless, the German organizers requested and received permissions from the Prague Jewish Museum to include a mini-exhibit of my sister Ritta's drawings from Terezín. In a strange way, this request underscored my feeling that no other experience was worthwhile enough to stand on its own when measured against the loss of Ritta, not even my mother's, and certainly not mine. But it worked out. My art, along with the work of my fellow artists, was displayed in a gallery at the fourteenth-century Nikolaikirche in Freiberg. Ritta's work was placed across the street in the municipal theater, which hosted a separate event,

including a reading by Freiberg middle school students from Helga Weissova's diary as a teenager in Terezín.

In preparing my work for Germany I had wanted to use objects my mother had brought from Europe: the linen napkins and kid gloves. But it soon became obvious that there would be potentially insurmountable obstacles to safely shipping and mounting these objects, so I made digital collages instead. I transmitted them to Stephanie and Kathrin, my co-creators in Freiberg, who then printed and framed them for display.

"Gloves Arado," the emblematic image from this exhibit, is from a digital collage onto one of the many pairs of gloves my mother had brought to California. The text portion of the image is a letter dated 1944 from the management of the Freiberg airplane works, Arado Flugzeugwerk/Freia GMbH (previously a porcelain factory owned by a Jew who committed suicide in 1939) to their superiors in Berlin, discussing the manufacture of airplanes for the Nazi war effort. It refers to the factory in a way which I suspect was intended to hide its true purpose.

The gloves symbolized everything refined and civilized that was crushed by the nation that gave the world Beethoven and Goethe, and everything that my mother had lost.

The evolution of the images for Freiberg had begun in about 2010–11, with a series called "Nest," where I had used imagery of my mother's prewar home in Kroměříž, overlain with the train route from Freiberg to Mauthausen, the Kroměříž synagogue which the Nazis burned, as well as maps of Soběslav and the image of the factory in Freiberg.

I found a tiny photograph of the living room of the home that my mother had just finished building with her beloved first husband, Alfred, in Kroměříž, when Hitler's troops arrived in 1939. My mother and Alfred had been together since she was seventeen, waiting ten years

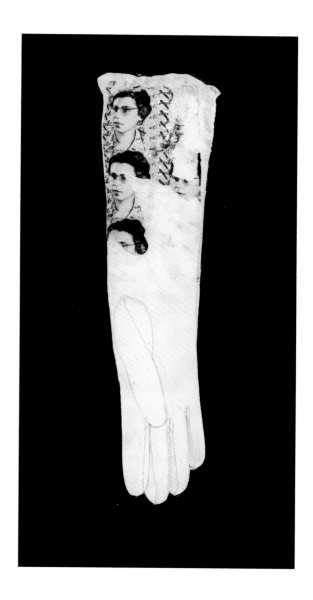

Glove: Opera Length (2015)
Collage on leather glove, 9.5 x 20 inches

while he finished his medical studies and established his practice as a pediatrician, before marrying in 1939.

> "Alfred and I found a nice lot in the middle of big gardens. There we built our house according to our specifications. On the first floor his offices and a walnut-paneled library with a big balcony to ours and our neighbor's back yards, all with huge, old trees and lilac bushes; upstairs had living quarters with one room for mother. Alfred insisted she could move in anytime, which made her happy. I can't say that we didn't make mistakes, but we loved the house. Alfred was more attached to it than I was. We bought a German shepherd and planted a rose garden, refusing to look at the world around us."

Within months, the Germans occupied Bohemia and Moravia, and their world was systematically constricted:

> "Jews were not allowed to leave their homes between 8 p.m. and 6 a.m.
>
> "Jews had to wear on their clothing a big, yellow star with 'Jüde' on it. To be caught without it, or hiding it on the street with a parcel, your arm, or something was reason to put you in jail with all the consequences.
>
> "There were coming out orders to deliver all your silver, gold and jewelry. With the diabolic system Germans are known for, this stuff was delivered to a bank as a 'voluntary' gift. I still have the official list stamped by the bank.
>
> "Not much later, all our radios, so they were sure you had no way of finding out what's going on in the world.
>
> "Here, again, you started to be completely dependent on your non-Jewish friends, who still came to your house in the evening to tell you what they had heard from England. It was forbidden to listen to England and, to supply a Jew with this news, very dangerous."

9. Return to Freiberg

Pavlovskeho 19, Kroměříž, 1939

Anmeldung [Registration document], 1939 (2015)
Digital collage

My mother was deported from Kroměříž to Terezín in 1942, along with Alfred, her mother, Elsa, and her immediate family, Uncle Emil, Aunt Netty and the girls, Lydia and Rita Brand. I made about a dozen variations on the theme of my mother's lost home in the "Nest" series.

In successive iterations, I changed the view out the living room window, to darkness, to a view of the factory in Freiberg, and finally to the route from Freiberg to Mauthausen.

9. Return to Freiberg

Pavlovskeho 19, Kroměříž, 1945, Night
(2012)

My mother's account of the trip from Auschwitz to Freiberg, in April 1945, of the "evacuation" and liberation, teaches about resilience, quiet courage, solidarity and perspective:

"The trip went slowly west, for which we were thankful. After a few days I got used to my semi-blindness, changing my only lens from one eye to the other, wearing it as a monocle, I must have been a sight. We were fed the usual coffee, bread and soup from a military kitchen

From Her Window, After (2012)
Digital collage

attached to the train, let out on a few stops to relieve
ourselves or to empty the pails.

"After 3-4 days, I don't remember now, we arrived
in Freiberg, Germany, about 30 km from Dresden, to work in
a newly established aviation factory. During the trip, we
established a friendship with some other girls, and so our
group of five tried to keep together."

Her spirit, solidarity and wit after two and a half years of imprisonment astonished me. She wrote about slave labor:

"They delivered two of the biggest machines to our
floor and we had to move them from the elevator. For that
purpose, they attached us to the machines with ropes, which
reminded us of the well-known Volga workers who, in the same
manner, pulled the boats upstream. There was also a beautiful song in Russian. Some of us got a stupid idea and we
started to sing that song and it didn't take long before we
were hit with the end of the rope."

My mother's attention to detail saved her life, more than once:

"We were issued tools; I got an electric drill and
was told to make a few 3 mm holes.

"In camp there was an important rule. You don't admit
that you are sick or that you don't know what to do. I
thought that maybe there were instructions on the drill, so
I studied the label carefully. Nothing there, except two
numbers. Not having anything else in my head, these two,
quite long [serial] numbers stuck in my mind ...

"... By that time, the RAF started to come more
often, and nearby Dresden was an important railway knot. We
were happy with every appearance. The danger of being killed
or harmed by a bomb seemed to us smaller than to be supervised by SS with guns. The basic rule was: The moment you
hear the alarm, and it was a horrible sound, you put your
tools down and line up. We were brought to the top floor
of the factory, where they drew heavy, dark curtains and

locked us in. The theory was that if the bomb should hit, we
should be killed, and they didn't want to be bothered with
injuries. By moving the curtains slightly, we were able to
observe the flights during the day. If we saw a plane being
shot down, and it happened a few times, and if we thought it
was an English one, the rest of the day was good for nothing.

"Coming back after one of these bombardments, I saw
that my drill was missing. I told my immediate boss and, of
course, his answer was that I was responsible. So what now
after this stupid answer. I asked to be brought right away
to the main office, that I might possibly have a way to find
the drill. He explained the situation to the head engineer,
and we got the same answer. I didn't give up and asked if
somebody could come with me because I knew the numbers
engraved on the label. I gave them to the supervisor, we
went through the whole floor and found the drill on a table
where I didn't have even the slightest chance of misplac-
ing it. The German worker stole it from my table and wanted
to sell it in town. I got it back and was smart enough not
to show any emotion when he told me that I had misplaced
it when I was running out after the alarm, in the opposite
direction. But the German honor had to be saved."

She was unforgiving of the Germans, to the end: a year before
she died, she declined to apply for a paltry increase in her reparations
payments, because, she said, they might expect forgiveness. But she also
credited those few Germans who treated her with compassion:

"Sometime during January (1945), I developed a tooth
infection. At first, nobody cared, but a few days later one
half of my face got so swollen and hard that I couldn't see
at work. Our Lagercommandant took me to a dentist in town. I
had to march ahead of him, he had a rifle with a bayonet,
people looking at us as though he had just captured the big-
gest spy in the world.

"At the dentist he explained that I was from a pris-
oner camp and, therefore, only the most necessary work was
to be done, not to waste any anaesthetic. When my turn came,

he wanted to come into the office with me but the dentist, also in some kind of uniform, told him to stay where he was, explaining that there wasn't room for extra people.

"I walked in, it was warm, clean and he was polite. Tears came to my eyes and, when he asked me if it hurt that much, I truthfully said, 'No, the tears are because it has been a long time since I was treated as a human being.'

"He worked using novocaine and told me, if asked by the guard, to tell him that it was very painful. I understood. He let me sit down for over an hour. I enjoyed every minute of it and gladly came back after a week for an unnecessary check-up. So, one can enjoy even a visit to a dentist."

When my mother retold this story about the dentist for her Shoah tape, she cried.

I have observed that when survivors are interviewed, they often attribute their survival to something they chose to do or not do: They joined one line or the other, they stepped forward, or back, they volunteered, or hid. In my father's case, there were split-second decisions and strategies that saved him when he arrived in Auschwitz:

"There was a big shouting outside, the doors were opened and orders were shouted, 'Everybody out, leave baggage behind in cars.' We jumped out, there were Gestapo guards along both sides of the train and a group of prisoners forming us newcomers in a single line. It was the first time I had seen concentration camp inmates in their striped garbs.

"Somebody behind me asked one of the inmates, 'Where are we?'

" 'In Auschwitz, you idiot, don't you know?'

"As we were standing in the line one of the inmates asked me if I have a fountain pen and a wristwatch. When I said yes, he asked me to give it to him. I didn't know if

it was an official request, but I was so confused and scared
that I gave him both. Then he asked how old I am. When I
told him forty-six, he advised me when I come to the table
before the doctor to say without waiting for the question in
loud voice, 'I am thirty-five and in perfect health,' and he
disappeared.

"The line started to move. When I came closer there
was a table with a chair on top of it and sitting in the
chair was an SS officer with a horse whip in his hand.
Overhead was a reflector pointing some 30 feet in front of
the table. As the men were stepping forward, the man first in
the line had to step in the spotlight and stand to atten-
tion. The officer pointed with his whip either to the left
or the right. According to the direction of the whip that
was the way each man was going. When the man in front of me
stepped in the spotlight he was asked his age and illness.
He said fifty and rheumatism. The whip pointed to the left
and he went that way. Now I stepped forward and following
the advice. I didn't wait for the question and said 'thir-
ty-five, in perfect health.' The whip sent me to the right.
Very soon I was told that the officer in the chair was the
infamous Dr. Josef Mengele, called the Angel of Death,
who sent by pointing with his whip without saying a word,
millions to death. The men who were sent to the left went
straight to the gas chambers. When I had heard it, I somehow
didn't miss the fountain pen and the watch."

My mother's own encounter with Mengele ended differently:

"After two days and two nights in what we thought at
that time cramped conditions (we learned later being shipped
from one camp to another could be worse), we arrived at
night in Auschwitz-Oswiecim. We were marched out to a spot
with bright lights, leaving everything behind us. And there
stood Dr. Mengele; at least I didn't know about him at this
time or what a selection meant. He pointed some to one side,
some to the other. One by one. When our turn came, Mother
and her friend to one side, me to the other. I honestly
didn't know what it meant, quick death in the gas chamber or

possible life, and tried to run over to Mother's side. An SS
man took me by an arm and pulled me back; I am pretty sure
it was not to save the life of a Jewish woman, but to inflict
more pain at that moment.

"And, since then, I believe in faith and destiny,
which proved to be so again some days later."

Was their fate determined by luck, rational choice, destiny, God?
No one is qualified to say they were wrong in their individual conclusions.
In listening to my mother and reading her manuscript, it appears to me
that in her case, a combination of fate, a refusal to give up hope, her own
attention to detail, her sense of honor and loyalty, and her willingness to
speak truth to power, were certainly contributing factors.

"Sometime later (in Freiberg) I got sick with a
fever and went dutifully to see the doctor at 4:30 in the
morning. Standing in line a girl next to me stupidly told
me that she was not actually sick but, being a dressmaker,
she would make a jacket out of a blanket for the good
doctor. When my turn came, the doctor refused me, said
she didn't have any free bunk left, which happened very
often. Looking straight into her eyes, I asked her, "How
long will it take for your jacket?" Surprised, she said, "I
still don't have room for you." So, I went back to work with
a fever of 102. After a few days I was better. To my sur-
prise, a nurse came in at 4:30 in the morning and I had to
see the doctor. They assigned a bunk in the sick room to me;
the doctor ignored me completely for the next two days. Who
cared! It was warm, I slept for the whole time except for
the meals, which were a little bigger ration to get our
strength back."

"Looking straight into her eyes...." My mother rarely hesitated—
with due regard for her own safety—to challenge dishonorable people.
And she never abandoned her friends.

Outside Her Window (2015)
Digital collage

9. Return to Freiberg

In making the images for Freiberg, I drifted a little from my commitment to reflect only what was factual and yielded to the temptation to try to change outcomes. Here, in my imagination, I rebuilt and restored the destroyed Kroměříž synagogue and placed it outside my mother's living room window at Pavlovskeho Street, #19. But the sadness still permeates: The room is empty. I cannot change the fact that no one came back.

Three weeks before my scheduled departure for Germany to attend the opening of my exhibit, I fell and broke my ankle, casting the entire trip into doubt. This fit into a pattern of my making traveling more difficult because I am hurt or sick. I never know if I should just stop trying to go anywhere or do anything. I wrote in my journal: "I am, as usual, becoming more anxious about the trip as the days wear on, but I am ready. And I am even ready to understand that the 'necessary' part of this trip has already been accomplished with the making of the art. And getting it there, and communicating about it with the Germans, as well as people here. My presence physically in Freiberg is in some sense superfluous."

In the days before the trip I became very emotional, crying more than I could ever remember, and every day I prepared for crying again. Every time I thought about some new difficulty—was my coat warm enough, did I have medications for every possible outcome? Would I get sick? Then I reminded myself that, if I was cold, my mother was colder on that cattle car and in that factory. If I was sick, my mother was sicker, with the starvation, the fear, the infections that could easily have killed her. So once again, as in so many other times in my life, I scolded myself, for complaining, for being afraid, for having petty concerns, because there is not and could never be anything that I can endure in my life that would be remotely as bad as what she endured. I wonder if I can ever let go of that piece of my self-inflicted suffering.

I sense that there are people who think that once I finished this task, and this trip, I would be "over it" and there will be nothing more to think or feel or do about it in my life. I suspect that is not how it will be. Just the more recent connections that I made with Hana and Eva and Wendy suggest that there seems to be, if not a unifying force, a fisherman out there who has cast a huge net over my lifespan and as I am aging it is being pulled in, so things that were separated are being drawn together. How else to explain that a trip to the Museum of Exiles on the French/Spanish border solved the mystery of the appearance of a Spanish communist surgeon in Mauthausen who repaired my mother's infected ankle in 1945? How else to explain my mother's and my discovery, fifty years after the war, in a book about Spanish Jews, of the identity of the sender of the package of chocolates addressed from Tangier to my mother in Terezín?

My mother said something about believing in Destiny when she was spared from the gas chamber at Auschwitz and when she looked out the window of the barracks at Mauthausen and watched a jeep of Russians enter the camp and then leave, followed by the American liberators. Although there is some dispute among historians about which troops entered the camp, and when, I trust my mother's account:

"And, finally, May 5 arrived. This is the way I recall it; again, maybe not historically correct, but this is my memory.

"We were in the barracks when the first Russian jeep passed our window and we saw freedom coming at last. Whatever the Russians did later or will ever do, I will never forget the most thankful feeling. I was later surprised when the girls told me that I ran to the window and recited in Hebrew 'the Shema Israel.' I don't consider myself religious but maybe at moments like that things in your personality come to the surface and you don't know how.

"We were happy and also rather surprised when in

the evening our Czech prisoner friends came to guard our
barracks during the night from the Russian soldiers. They
knew better than we did."

This is as close as she ever came to talking about sexual abuse in
the camps.

I left for Germany close to Passover. I knew that on Passover in
1945 my mother was still in the Freiberg camp. So, during our Seder with
friends that year, when we talked about liberation and the prescription
that each person in each generation must relate as though she, herself
were coming out of Egypt, my sadness was overwhelming. I thought
about the narrow straits. Mitzraim (the Hebrew name for Egypt). My
own Egypt. I wondered if I will ever be free.

It is no wonder that every detail of the preparation for this trip
was fraught with dark, anxious feelings and grief. As I packed my suit-
case, over and over, and made my lists of the things I must have with
me—iPad, cords, camera, passport, money, medications—I imagined the
deportation order and remembered my mother's description of spending
days and days packing and weighing and repacking to bring exactly 50
kilos of luggage to Terezín. And I think about all the people she loved
who also packed their 50 kilos, the family they hoped to be reunited with,
and never were. So, my usual reluctance and fear about being separated
from my own little family was compounded by multiples.

I began to understand that even though I have accepted my
tasks regarding this Holocaust memory work, and my need to actually
be someone of consequence in the world to make up for all my parents'
losses in this life, I was tired and a bit worn out, and there was a part of me
that hoped that this trip would put me at peace with what it is I had to do
or had left to do, specifically in relation to my family. I hoped to develop
the courage and self-discipline to sit quietly and wait for the future or

the next phase of my destiny to reveal itself to me so that I can proceed mindfully and intentionally, rather than in a skittering panic over the passage of time.

On the drive to Dresden from Berlin, I kept looking at the birch trees alongside the highway. I remembered that on our earlier trip in 2007, we had found a small memorial in Berlin at the contemporary art space. A Polish artist had brought hundreds of the birch trees from the forests around Auschwitz to Berlin and planted them throughout the city. Even though I grew up surrounded by birch trees in Montreal, with no thought or understanding of this connection, I will not be able to look at them again without this association.

Upon our arrival in Freiberg, Michael Duesing was waiting to take us on a tour of the city. We saw the high school where Michael had taught, which has been named for Hans and Sophie Scholl. I asked for a stop at the airplane factory memorial, and also to see the route the prisoners walked from the factory to the barracks. I wondered how far the women walked every day in their noisy wooden clogs. I was wearing my clogs—or one clog and a boot—making it possible for me to walk almost normally on my broken ankle.

Maybe my mother would want me to walk along that route. Her stations. Maybe I want to walk along that street, to look in the windows of the houses, to stare in at the descendants of the Freibergers who had been so annoyed to be awakened by the noise of the slave laborers going by on their way from the barracks to the factory.

Back at the site of the factory on Frauensteinerstrasse, Michael expressed his upset that they had placed the memorial plaque for the Freiberg women inside the alcove at the entrance, rather than on the front of the building where any passerby would have to see it. You do

9. Return to Freiberg

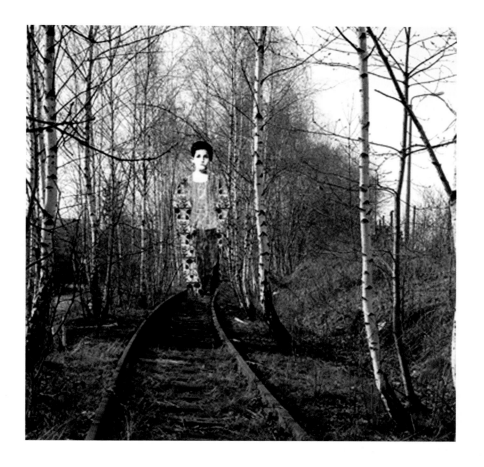

Boy on the Track Among the Birches (2015)
Digital collage on photograph

have to be looking for it to realize that anything untoward had happened there. Here as elsewhere, the seekers of knowledge are those who already have it. So it is, as it was when I dropped the note in 2007, a place to put a stone or flowers for those who already have that specific reason to be here. And those who don't know, sometimes still don't want to know. At lunch in the Italian restaurant across from the Hotel Kreller, a German man interrupted us to ask whether we were from New Zealand, or where, he was having trouble placing our accents. He asked, first, what was the best thing about Germany, from our point of view, and what in the world we were doing in such a small town as Freiberg. We told him why we were there, and he quickly disclaimed any knowledge of the factory or the slave laborers. And he turned away from us.

Michael had decided to call the exhibit "We Are Still Here / Wir Sind Doch Da." The passion and the commitment of the people involved in this project amazed us. There was a contingent with a German non-profit concerned with Terezín that holds the rights to Helga's teenage drawings, the people involved in Michael's history project, and Kathrin Krahl's group of Dresden anti-racism workers. Kathrin works in her day job on anti-racism and anti-Semitism. As she described it, it was currently very depressing and frightening, what was going on in Dresden and southern Germany generally with Pegida, the nascent proto-fascist party. She described how in particular Eritrean refugees in Dresden were being physically attacked on public transportation, so her group bought, or found, seventy bicycles for them so they can get around the city. There was a contingent of young feminists who interviewed my husband about how to respond to an anti-choice rally planned for Dresden in the next two months. They had learned in conversation that Richard has worked for years with Planned Parenthood. The irony of the Nazi position on abortion had not escaped any of us: Jewish women in the ghettos were required to abort, on pain of deportation to Auschwitz, and certain

death. German women—limited to the domain of *Kinder, Küche* and *Kirche* (Children, Cooking and Church)—were prohibited from terminating pregnancies. It seemed to be all connected.

In the morning we went to rehang the art so that I could sign it. I told Michael they could donate it to schools or donate to the history workshop at the conclusion of the exhibition. As with the work in Prague and Terezín, I wanted to leave it behind. The reading of Helga's diary at the theater brought out about a hundred people to hear three middle school girls and one in high school. The younger ones attend the school that was built on the site of the Freiberg barracks, so they do something every year for remembrance. The twelve-year-old, Hana, was trembling and tearful. I was afraid that she was too young for this. I thought of my granddaughter Sophia, then twelve, but also that Ritta was gassed at twelve, and of course Helga Weissova was deported at that age. So it was right and fitting, and she got through it.

The event in the Nikolaikirche drew in a lot of people, probably because of a news article by a local reporter, Frank Hummel, which was very well done. There was beautiful music performed by three women, a Dresden opera singer, a pianist, and an oboe player, who played contemporary klezmer music, traditional for the Eastern European Ashkenazi Jews. I would have preferred "Songs from my Mother" by Dvořak, but this was very good. I reminded Helga how much we had enjoyed the piano and cello performance by her son and granddaughter Dominika, who had played for us in Prague eight years earlier. Helga told me that Dominika is only a quarter Jewish, through her grandmother, had two small children and had become quite religious—"frum"—she said in Yiddish. Helga said she had celebrated Seder that year but didn't remember ever having done it as a child. That is part of a strange renaissance—a rebirthing of a life that had never really existed before, among the prewar assimilated Jewish community.

The political and historical speeches were heartfelt and well done, they seemed to really care about what they were saying about tolerance and democracy, and the threats to it, which were already very grave in Europe. I said these people had redeemed Germany, but that was not quite accurate. They are mightily trying, with all their hearts, but these forces are so big and so terrifying....

On our last night's celebratory dinner in Freiberg, the young German artist Stephanie Busch said to me as we were leaving the restaurant, "[it] all started with the note you left. You have changed the history here." I was amazed, because sometimes I think that this—changing history—is exactly the task that has burdened me all my life and made it impossible for me to find peace or happiness within it. Is it possible that I have actually done what I am supposed to do? Or that I am doing it, and that this is the way I should/must continue? And is this artwork and this particular story the only story I am ever supposed to tell?

The last five years have convinced me that I can never really be finished, that memory is always vulnerable to abuse. At the same time, as I advance in years, realizing my own time is limited, I must find a larger context.

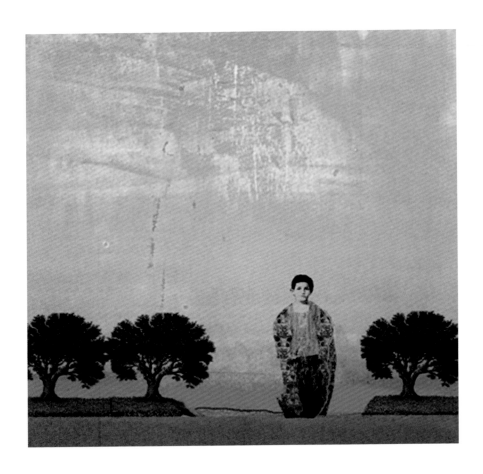

Big Jew (2015)
Digital collage

Jerusalem Bienniale 2015/2019

Through my work after Prague and Freiberg, I have continued to explore my place, not only in the history of the European Jews, but also in the geography of the Jewish spiritual tradition, as well as to explore multiple layers of exile/Diaspora/Galut. Making art helps me to understand my own life narrative, reminds me to accept, if not embrace, my perpetual state of discomfort and ambivalence, and to make connections with others who may see their own struggles reflected in my work.

I called this piece "Big Jew," to acknowledge how much space is taken up by the image of the Jew in Israel. I took multiples of the image of an olive tree (a symbol of Palestinian attachment to the land) and placed my Uncle Fritz in the picture (from a photo taken in 1916), wearing a tallit made of Portuguese tiles.

The second image shown in Jerusalem was also challenging. The image is of my granddaughter on the day of her Bat Mitzvah, superimposed on the Kotel, or Western Wall, where women are still struggling to be permitted to pray on an equal footing with men. I am continually impressed that in Israel such commentary is readily admitted to exhibitions, while here in the United States, the "organized" Jewish community has historically not welcomed it.

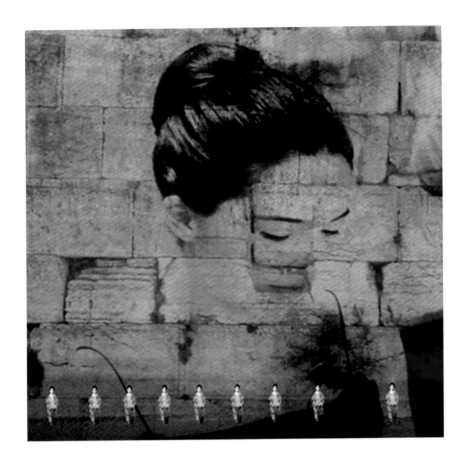

Girl at the Wall (2015)
Digital collage

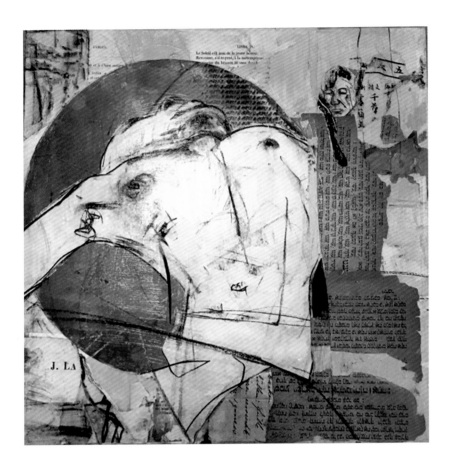

Chaos Theory (2018)
Collage on wood, 10 x 10 inches

Kolař/Kolaj
Collage as Memoir 2019

Every year, on no particular day in the month of May, I notice the absence of the scent of lilacs here in southern California and I realize that I have missed spring in Prague, again. And in Montreal. Lilacs were my mother's favorite flower, and I have internalized the idea of lilacs as a reminder of home, even though I find their fragrance overwhelming.

In May 2018, I received an invitation to participate as a panelist in *Kolaj Fest*, a symposium on collage, to be held in New Orleans in the summer. I learned about this opportunity through a magazine called *Kolaj*, which I was attracted to initially because this title looks close to the Czech word for collage—koláž—and I read that the magazine is based in Montreal, where I was raised, so I subscribed. I have to smile at how I grasp at any and all symbols of my roots, no matter how attenuated the connection. But there is no denying that this invitation to participate in the fest brought an opportunity to explore once again where I stand in relation to my identity and history.

I first noticed the work of Jiři Kolař in an exhibit in Paris in the early 1970s, when I was still a graduate student in French literature and linguistics. I was especially struck by his use of text, which had a visceral appeal for me. It brought to mind my studies of the French poets and

painters: Apollinaire, Mallarmé, Max Ernst. My attraction to Kolař's work and to the suggestion of narrative, or a naming process, reflects a continuing need in me to use stories to express the core of an emotion or experience. This, in turn, may derive from my not being able to hold six million deaths or the larger story, and with needing to tell or mark in some way the individual stories, if not of the six million, at least of my most loved ones. Or the ones I would have loved if I had known them. Reconstructing these lives, arranging the remnant and the fragments in a new context, layering the memory onto a current reality or even onto an imagined, brighter future have all become elements in my collage work.

Fragmentation and destruction have been constant themes in my life and in my work. But my attraction to the work of Jiři Kolař goes deeper, to the particulars of searching for my own identity, trying to find what it means to me to be a Czech Jew. Or a Jew originating in the Czech lands who has not lived there in seventy years and neither speaks nor reads nor writes Czech. Kolař, like me, was an émigré, escaping from the Communists to Berlin and Paris. But he left his homeland much later in his life than I had. I was not quite two years old, a notation, a footnote without a name, on my father's passport. "Joseph Zimmer ... and child." Since I had latched onto Kolař, I wanted to know whether we were otherwise alike, so I started to study his work.

I finally read the book that I had purchased at the Kampa Museum in Prague several years earlier called *The Stories of Jiři Kolař*. I am fascinated that Kolař's collages are called "stories," that he was someone who bore witness, in words and visual syntax, to the suffering of others. His literalness was described as "material evidence of the historical process." So, I think I am with him on intention, but I differ in expression. His seems a much more sophisticated and thought-out form. I am not interested in formal qualities so much as in finding a way to connect myself to my shattered past, since I cannot escape it. In this sense, I make history,

my history, to the extent I carry it in my cells. I am fascinated by the uncanny fact that this book has resurfaced in my library at this particular time to help guide me in this search.

The Kampa Museum in Prague owns about twenty-five of my monotypes, which I donated after exhibiting them at the Jewish Museum in Prague in 2007. That donation occurred after a series of apparently unconnected coincidences, a scattering of sources. An art collector acquaintance of mine in Santa Barbara introduced me to Madame Meda Mladek, a wealthy Czech émigré who, with her husband, Jan, an executive with the International Monetary Fund, had also fled the Communists in 1948. They returned to Prague after the Velvet Revolution, determined to return to their source the works of modern and contemporary Czech artists who had been persecuted, jailed, banned or forced abroad by the Communist regime. Together, they built the Kampa Museum, and they reconstructed the memory and the reputations of these reclaimed artists. Because of Mme. Mladek, the Kampa has an extensive collection of Kolař's work. And mine too.

A second book that has been lying around for a while popped up into my mind—*Surrealist Collage in Text and Image: Dissecting the Exquisite Corpse* was given to me by my son and daughter-in-law for my seventieth birthday. It does not mention Kolař and focuses instead on the French surrealists. But everything that was happening in Paris between the wars was also happening in Prague. The art, the architecture, and the surrealists cross-pollinated. Kolař was himself associated with the Czech post-surrealist organization *Group 42* in the 1940s. I started to read the book but gave up after a few pages. It reminded me too quickly that I never really liked the French surrealists, or the academics who analyzed them. It seemed to me that all they did was play clever games. Like the exquisite corpse.

Excerpt, Jiři Stern's Terezín Notebook, 1942

In searching my image bank for appropriate images, not to illustrate but rather to speak through this writing, I come upon a series of collages that were done contemporaneously with living the experience of Terezín, a diary written by my father's friend Jiři Stern, who I knew all my life as "Uncle Jirka." He was deported to Terezín in his late teens and produced an amazing booklet, which somehow survived, of collage and writings satirizing his experience there as a young man. Simona showed it to me on one of my visits to Prague. I quickly photographed a number of the images. It is a most moving artifact, beginning by describing the deportation of the Stern family from Prague: "In June of 1942 we had the idea of taking a vacation in Terezín for a few weekends...." Jirka and Karel and my father never stopped with the sardonic and sarcastic descriptions

Change in Menu (2014)
Digital collage from Jiři Stern's Terezín Notebook

of life in the camps. Reading this notebook, I was reminded of how Karel and my father never stopped joking, even while we ate lunch at a restaurant in Terezín next door to where Eichmann's office had been.

I appropriated and inserted Jirka's sardonic commentary and his deportation number, 136, into an image from an altered photograph of the Bois de Vincennes in Paris, across from an apartment where we had once stayed. This urban wood has, in turn, shown up in many of my digital collages.

For example, I restored my mother's synagogue in Kroměříž in these woods, where it had never been.

Kroměříž, Temple, Reimagined in Winter (2013)
Digital collage

My connection to collage as a favored means of expression continues. In 2019, I again accepted an invitation to participate in a collage symposium through *Kolaj* magazine, this time in Montreal. This was my first trip back to the city in more than twenty years. My parents and I had left for California in 1963, when I was sixteen. I returned in 1971 and again in the early nineties on our way to a sailing trip in Guadeloupe. On the second visit, we searched for and found the apartment house where I had lived before I was seven. We discovered that the vacant, forested lot in the next block on Côte Ste Catherine Road, where I had played as a child, is now the site of the Montreal Holocaust Museum. A stone's throw.

On this most recent visit, in 2019, I explored for the first time the old Jewish neighborhoods, the ones I had never known, because the survivors' wave of immigration came after the war, when Jews were starting to move out of those neighborhoods and into the suburbs. Searching through deeper layers of history, and for my place in it, each time.

I am continuing to explore how text and image speak to and through each other, sometimes in the moment of putting them in the same space or on the same page. In my hundreds of pages of words and images, there is a lot of obsessive revisiting of themes, and I see I have called out Montreal scores of times. I had thought I did not remember any of my childhood there. But the manipulation of imagery brings up memories to add to the story. And the act of writing prompts more manipulation of images into collage.

This notion of home continues to baffle me. I am home in Prague when I smell lilacs, or eat sauerkraut with bread dumplings, or Oblatentorte, and when I am staying with Simona in Podolí. I am home in Montreal, also, when I smell lilacs, or eat smoked meat on rye, or pea soup. I stood crying at the wall in Jerusalem. But my roots are not at the bottom of a well, there. Or are they?

I have always romanticized this notion of home and belonging. Connection. I want a place and a people who would wholeheartedly welcome me and take care of me. I have never had that, and now I see that I never will. I wondered about whether there was any ambivalence in the Czech psyche about this. After all, the Czech "nation" was itself an artificial construct; an arbitrary melding together of varying degrees of Slavs—urban Bohemians, Moravians—with their close connection to Vienna and the much less cosmopolitan Slovak farmers in Slovakia. I remember yet again that the title of the national anthem begins with a question: *Kde domov můj*? (Where is my home?)

I became intrigued by the very idea of a nation whose stirring anthem posed such a paradoxical question. I wrote to Simona to ask about it. Simona is an interpreter of Czech/English who works at the European Union in Brussels. Her response to my question was matter of fact. She wrote:

"The anthem starts with a question. It goes on to provide the affirmative answer in:

"*A to je ta krásná země, země česká, domov můj, země česká, domov můj.* And this is the beautiful land, the Czech land, my home, the Czech land, my home."

Soon after my exchange with Simona, I awoke at about 4 a.m. after a very strange dream. In this dream I have been selected by a mysterious woman, whose authority no one questions, to conduct Mozart's "Don Giovanni." I have no background in music and would not recognize the notes of "Don Giovanni" if I heard them. In the dream I am more worried about the fact that the tuxedo that has been specially made for me seems to have lint on it, than the fact that I do not have any music, don't know the score, and wouldn't be able to read it if I had it. But I am standing with the baton raised, knowing that the downbeat —I assume it is a downbeat—is coming, the curtain has been parted, and I am exposed.

11. Kolař/Kolaj/Collage as Memoir

I am mystified by my dream choice of this opera. I know that it is about a seducer and cheater who goes to hell. When I look it up, I see that it debuted in 1787 in Prague, at the Estates Theater. Kafka was right: "Prague does not let go—"

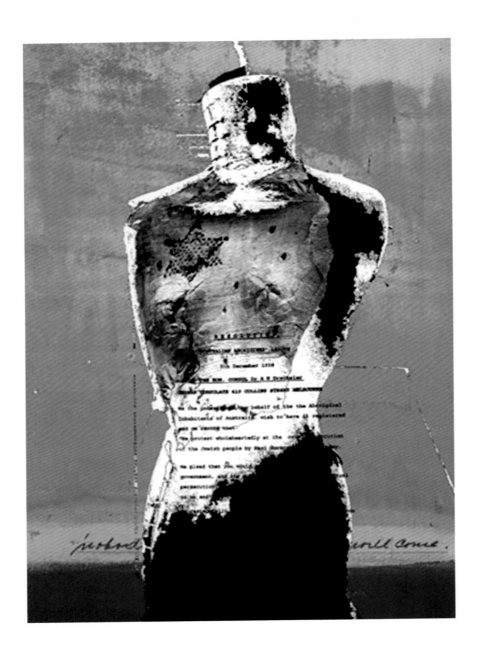

Inside Out (2018)
Digital collage

By the Rivers of Babylon...
Memory and Mourning

Even as my time is running out, my questions about my place in the world return. This image once again incorporates my early monotype "Nobody Knows When" as background, upon which I superimposed a digital collage comprised of a photograph of a sculpture and an unrelated document that I found at the Jewish Museum in Melbourne, Australia. The sculpture is a hollow dressmaker's mannequin—my mother was a dressmaker—with apparent bullet holes in the chest and a yellow star on the inside of the chest area, as though hidden. The document is the letter written in late 1930s by the Australian Aboriginal Council to the German consul objecting to the treatment of Europe's Jews by the Nazis. I was astonished that the Aboriginal Council knew what the Nazis were doing, and from 8,000 miles away, they registered their strong objections. They could see and took a stand against the atrocities that Neville Chamberlain and Franklin Roosevelt and the International Red Cross refused to acknowledge. My mother would have been pleased to hear about these "upstanders."

This piece became my page in an artists' book submitted by members of the Southern California Jewish Artists' Initiative to the Jerusalem

Biennale in 2019. In addition to the book there was a video component of all the participating artists commenting on their role in the exhibit, their artistic practice, and their unique relationship to Israel as Jewish artists living and working in the Diaspora.

My mother rarely showed bitterness about her wartime experience, except to challenge the lies of various people—her own neighbors in Kroměříž, who collaborated—and the Austrian villagers who lived near Mauthausen, who claimed they didn't know about it.

My mother was an empathic person as evinced by her literal order to me, as a seventeen-year-old, to go to my first Civil Rights march. She taught me that neutrality is a weapon of the oppressor, and she wanted me to be an upstander. But she was not overly preoccupied with forgiveness. She didn't and said she never would forgive the Nazis and had no hesitation or shame in sharing her views about the correct treatment of collaborators after the war.

"I have to come back, if only for a moment, to our last German maid. She stayed with us a little longer for whatever reasons. I never saw her later and heard about her only when I came back in 1945 from the concentration camp.

"It was a rather strange and unsettled time, the local government setting themselves up as the 'people's court,' by which people sometimes tried to settle their personal animosities. This woman, I forgot her name, was sentenced to be hanged for strong and ugly collaboration with the Nazis. Some of her relatives somehow found out that I came back and supposedly asked, not me directly, if I could put in a good word for her. They certainly turned to the wrong person, me coming back from Mauthausen all alone and starting to realize that maybe nobody else would come back. I didn't react to their request, and they took care of her the next day. It didn't bother me at all.

"As a matter of fact, the next day they took care of another acquaintance of mine. He was a bigger wheel in the

Nazi party in town and, among other things, had confiscated my bedroom set when we were deported. I got it back and he went to hell."

My mother always projected a cheerful, optimistic demeanor to the outside world, but her anxiety and her anger lived on in her. It seems inevitable that I internalized both.

As for my father, he never said much, and he never encouraged me to be an upstander. To the contrary, when I became involved in the Civil Rights and anti-war movements in the 1960s, he expressed that I would be the cause of a new deportation order for the whole family. He never said a word about his feelings, not in his manuscript, nor in person, not even on his deathbed.

Forgetting Jerusalem (2020)
Digitally altered monotype

Epilogue: Return?

Viktor Ullmann, a Jewish composer who was imprisoned in the Terezín ghetto at the same time as my parents, wrote about the inmates' efforts to continue a cultural life in those miserable circumstances. The composers and conductors organized performances of arias from "Aida," the children performed "Brundibar," and the artists depicted conditions in the camp for posterity.

Ullmann said, "By no means did we sit weeping by the rivers of Babylon; our endeavors in the arts were commensurate with our will to live." Like such other assimilated German-speaking Czech Jews as Kafka and Mahler, Ullmann lived a life of multiple estrangements, cut off from Czech nationalism, German anti-Semitism and Jewish orthodoxy. He was born in 1898, the same year as my father, and like my father, he had served on the Italian front in the Austro-Hungarian Imperial Army. I find it interesting that he chose to compare his situation in Terezín to the exiles from Jerusalem, weeping by the rivers of Babylon, invoking the famous verse from the 137th Psalm.

The other most well-known verse of that Psalm is reflected in one of my earliest monotypes, which was inspired by the gravestones

in the medieval Jewish cemetery in Prague. I called it, "If I forget thee, O Jerusalem...."

The exile from Jerusalem, and Zion, has been the foundational Jewish theme for 2,500 years. In 586 BCE, the Babylonian empire conquered Jerusalem, destroyed the first temple that had been built by King Solomon, and uprooted large numbers of people, deporting them hundreds of miles to the east. This tragedy is mourned in the psalm. The second tragedy mourned by the Jews on Tisha B'Av was the destruction of the second temple and the beginnings of the Diaspora. Then followed other tragic occurrences: the medieval tortures, the expulsions from France, from Spain, the deportations and dislocations of the Holocaust, the systematic expulsions of the Mizrahi Jews from the Arab countries where they had lived for millenia. I envy them all the memory of home, the ability to weep for a place to which they feel a deep connection, even if it has been lost.

But my heart has also declared itself. Despite my sense of outsiderness, when I arrived in Jerusalem for my first and only visit in 1995, I called my mother to let her know we were safely ensconced in our hotel on Mount Scopus. My throat closed with tears as I said, "Mami, we are here, we are in Jerusalem." And the first morning, after a massive Middle Eastern breakfast, I walked as though a homing pigeon, following a signal through the Old City, with no fear of becoming lost in the labyrinthian old streets, and reached the destination of every pilgrim. I inserted my prayer in a crack in the Western Wall and wept tears of connectedness.

On the evening of Yom Kippur in the year 5779 according to the Hebrew calendar, I went to synagogue to hear Kol Nidre, the prayer known as "All Vows," which is chanted a few minutes before sunset, just before the true beginning of the mandated twenty-five hours of fasting and atonement. The service was particularly moving because there was

Prayer text
Photograph courtesy of the author

a cellist who played the ancient melody, complementing the Cantor's chanting. The chant always brings me to tears, even though I have never understood the words.

That year, there was something new in my hearing of the cello, other than the melancholy; something I have never noticed on any recording. I was stunned by the cellist's use of a technique I have learned

is called the "double stop." I had no idea that one could play two notes simultaneously on a single cello. The notes seemed at war with one another, pulling at each other, just as everything about Kol Nidre is paradox and contradiction. It is probably the most well-known chant in the liturgy, but it is not a prayer at all; it is a legal declaration. It does not ask anything of God but announces the annulment of all vows made to Him, either in the previous year or for the forthcoming year, depending on the interpretation. It is not in Hebrew, the ancient language we associate with the Israelites of the Bible, but in Aramaic, the *lingua franca* of the Babylonian exile. It dates from the time of the earliest deportations and persecutions, and it triggers more emotional response in me than any other chant. I don't return to synagogue every year to pray my own words, but to hear Kol Nidre, to be infused with it.

As much as Kol Nidre brings forth "identity tears," every year I return to the question of whether I belong to and in the Jewish community. This is fitting to the season, because the entirety of the Days of Awe is about T'shuvah—return, atonement and forgiveness. By sunset on Rosh Hashanah, the turning is complete, or not, and God decides if our penitence is sufficient and if we will be inscribed in the Book of Life for another year, or if we will succumb to our mortality and by what means—"Who by Fire, who by Water...." I read in the new prayer book that whether T'shuvah is complete depends not on whether God forgives us but on whether we can forgive ourselves. That makes sense to me and may explain why I have been unable to maintain the feeling of having truly returned, and so I must do it again, and again. I see that there are things for which I cannot forgive myself. I just do not know what they are.

The opening chant of Kol Nidre, and the Yizkor (Remembrance) service on the afternoon of Yom Kippur, about twenty-two hours into the fast, are the bookends of my annual religious commitment, and my questioning. This, and the visit to my parents' graves between Rosh

Hashanah and Yom Kippur in the seaside cemetery where I go to hear whatever wisdom they may offer me. I know cremation is frowned upon in the Jewish tradition, but it is what both my parents wanted, in preference to a spilling of their ashes at sea. They wanted to have a simple grave marker with their names and dates, to set the arc of their lives in time, and so someone could visit them. "Too many unmarked graves in the family, too many people we never found," my mother said when we moved my father's ashes.

Sometimes, depending on how hungry and headachy I feel, if I have been observing the fast, I stay after Yizkor for the final blowing of the ram's horn, the Shofar, to face east toward Jerusalem as the sun sets, and to hear the final assertion-wish-hope, "Next Year in Jerusalem." This is yet another contradiction and is perhaps the ultimate stumbling block to holding onto a feeling that I belong with these people. We Jews also say this at the end of the Passover Seder to remember our liberation from slavery in Egypt, and it brings a lump to my throat. So, from the beginning of the Yom Kippur service to the end I am reminded of my feelings of being in exile, and simultaneously of my desire to return, but to what, since the dictates both of the God of Moses and the modern Jewish state—or what it has become—inspire a slightly nauseated, ambivalent loyalty in me, at best.

My mother was intent on holding her memories close. On Yom Kippur, even when my father wouldn't tolerate attendance at a synagogue, without fail, my mother lit the twenty-four-hour memorial Yahrzeit candle, sat at home, invited a shroud of gray into the house. There was silence. She sat Shiva alone. Was she thinking about her mother, Elsa? The Kremsier, the girls, Rita and Lydia? Alfred? Happier days were reconstructed in her mind, I hoped.

It does not surprise me to read that there is yet another way to understand the destruction of Jerusalem and the dispersion of the Jewish

people. According to the prophet Jeremiah, the reason for the Babylonian exile was that the people did not let the land rest every seven years, as is biblically mandated. The Torah teaches that God will take the side of the land against the people if forced to, and that the land will "enjoy her Sabbaths"—even if that means the people are exiled or wiped out. What has intrinsic value is not humanity, but humanity's potential to do justice. As I write this, it seems we are on the brink of that exile, as well.

Justice/art/justice-through-art—these have been the entwined themes of my later life. So, the same color purple that I have placed inside the fractured temple in Jerusalem, and which reminds me of the purple salvia I planted for my mother when she died, also stands for the wounded planet, and a prayer for its healing, and for our healing as well.

My father was a cynic. My mother was a mystic, in spite of herself. She kept her beliefs under wraps while my father was alive. She probably never knew—because she never studied it—that in the Kabbalah, the ancient Jewish tradition of mystical interpretation of the Bible, the Fall is the catastrophic moment at which God's Shekinah, his Divine Presence, was exiled from the primordial Divine Ground, the Ein Sof. The goal of all existence is the overcoming of the cosmic galut or exile and the restoration of the cosmos to its seamless unity.

These themes of Exile and Return have become more urgent as I approach the beginning of what will certainly be my last quarter century. This whole discussion of who dies, what dies, is the core issue. Dying into the light? Dying into the void? These questions became more urgent as the pandemic has forced me to focus on the archetypes of change, in no particular order: Transitio, Separatio, Mortificatio. Awareness, differentiation, death/grieving. I am inexperienced in Jungian systems of thought, in alchemy or astrology, so I went back to my own 5782-year-old "DNA" to look at the Hebrew letters. I am still ignorant of their meanings, still do not know how to form them into words, but they feel familiar to me.

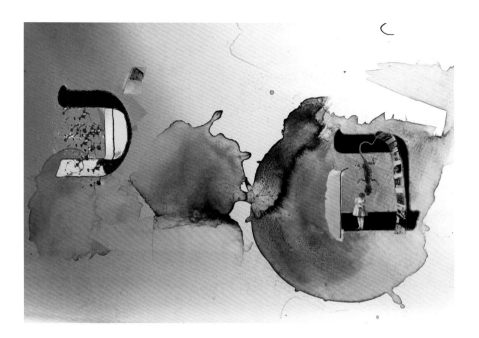

She Weeps (2021)
Digital Collage

The letters Bet (House) and Khaf (Container) asserted themselves first. Contained within the Bet, (duality), are my Girl and her Reptile, two symbols I have chosen. Next to the moebius strip of my lifespan, the Girl is looking away from something bloody. The reptile hangs over her. My eye continues right to left, as the Hebrew must be read. Something essential passes over a void to reach the Khaf. The infant floats above, as if waiting to be incarnated. The Girl has become pure Light. Her reptile has disintegrated into abstract/expressionism, a happy accident: my watercolor marks had seeped through to the back of the paper.

I start to wonder what words these letters might form, so I contact my Rabbi. He raises possibilities, for the Bet:

Baruch (blessed)
Banayich (your children)
Bitnech (your womb/belly)

And the Khaf:
'K'ruv (cherub/angelic being)
Kotev (writes)

He says, "When I look at these two letters as they appear here the word that comes to my mind most powerfully is:
Bechi..... meaning 'weeping'
Or bacha..... meaning 'wept'
Or bocha..... 'she weeps.'"

Bocha—she weeps. I am stunned with recognition. I feel tremendous sadness, and tears I cannot shed, at the back of my eyes. Now I think that the reptile has to do with unresolved grief. I place him, with the Bet and the Kaf into a new collage. I add the moebius strip of my life, and myself as an infant, sleeping, unaware of the veil that my father's life story has cast over my face.

I wrote to my Rabbi:

"I love what the Bet and Khaf suggested to you. *She is weeping.*

"I opened the Khaf at the end as you suggested. And I added a Yud, above the Bet."

He responded:

"The yud is floating in an ambiguous position. If it is above the rest of the word it feels like a hint of God's name which is sometimes represented simply by yud. If it were to go before the word, then it puts the verb into the masculine future tense. "Yivkeh" means "he will weep."

He will weep, she weeps, now.

"But," he continued, "I have been drawn all along to the curved strip and the lizard, both of which seem to be functioning as added letters in the word. If the curved strip is a 'resh' (which it looks like to me) and the lizard is a 'vav' (which it looks like), then the word (without the yud) becomes 'bruchah' meaning 'blessed' (as a feminine adjective). And the yud is what is referred to as 'The Above.'"

I immediately think of the phrase, "As Above, so Below."

My final image, on watercolor paper, adds an ancient door; the Girl appears to be looking down toward it. I think there must still be more to see, Below.

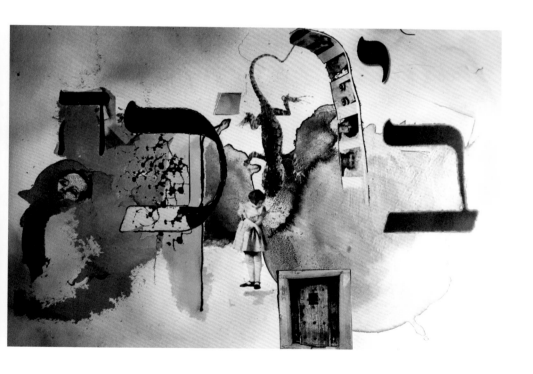

Blessed (2021)
Digital collage

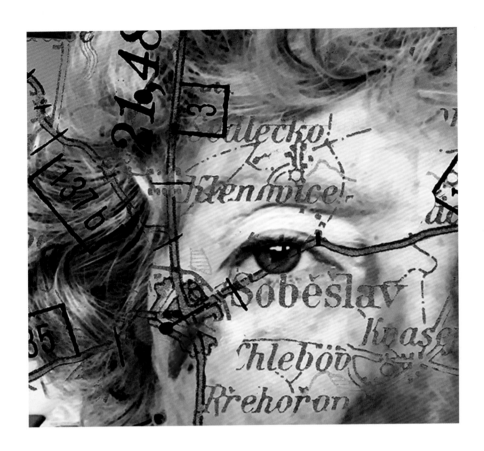

"Where It Started..." (2015)
Digital collage

About the author

Jana Zimmer was born in 1946, the only child of two Holocaust survivors from Czechoslovakia, who fled with them as a refugee from the communists to land in Canada days after her second birthday. Zimmer became a collage/mixed media artist after her mother came to live with her in 1995. In her artwork, through text and image, she explores issues of memory, exile, and responsibility. She currently resides in Santa Barbara, California.